THE VIDEO CAMERA HANDBOOK

THE VIDEO CAMERA HANDBOOK

NIGEL TAYLOR

Published by SILVERDALE BOOKS
An imprint of Bookmart Ltd
Registered number 2372865
Trading as Bookmart Ltd
Blaby Road
Wigston
Leicester LE18 4SE

© 2004 D&S Books Ltd

D&S Books Ltd
Kerswell,
Parkham Ash, Bideford
Devon, England
EX39 5PR

e-mail us at:-
enquiries@dsbooks.fsnet.co.uk

This edition printed 2004

ISBN 1-856058-84-0

DS0090 Video Camera Handbook

Creative Director: Sarah King
Project editor: Judith Millidge
Designer: 2H Design
Illustrations drawn by Corinne Czarnecki

Set in Adobe Garamond and Clarendon

Printed in China

1 3 5 7 9 10 8 6 4 2

CONTENTS

NEWCASTLE-UNDER-LYME
COLLEGE LEARNING
RESOURCES

INTRODUCTION

'The image of the dummy's head formed itself on the screen with what appeared to be unbelievable clarity. I ran down the little flight of stairs to Mr Cross's office, and seized by the arm, his office boy, William Taynton, hauled him upstairs and put him in front of the transmitter.'

After paying William two shillings and sixpence to stay in position, Baird finally saw a human face recognisably reproduced on his apparatus.

And so it was that in September 1925, William Taynton went down in history, as the very first person to appear on television!

Four months later on the 26th January 1926, John Logie Baird demonstrated his mechanical system of Television to the Royal Institute and a reporter from *The Times* newspaper.

The rest is history - but it is only relatively recently that television has come within the grasp of home enthusiasts. In early 1970 the very first black and white, one-inch video recorder called a Shibarden was available. Broadcasters used these for detailed planning of editing before the main edit which took place on very expensive videotape machines.

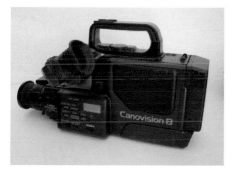

Then later, in that same decade, after winning the war with Betamax, came the VHS format. Still around today, this is the key innovation that kicked off the home video revolution. The ability to record TV programmes resulted in enthusiasts wanting to make their own images. Video cameras could be plugged in the back of the VHS, and their output recorded on tape. So the first video cameras were produced for home use.

It wasn't all that long ago that you needed a small suitcase to carry a video camera around - well not anymore. Today they are small enough to fit into a shirt pocket and they also come with an array of features never imagined in a camera twenty years ago.

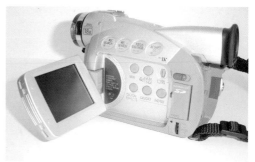

Above: An early 8mm camcorder dating from 1987.
Right: A modern DV camcorder with pull-out monitor.

Back in the early 1980s a video camera was a large and expensive luxury owned only by enthusiasts. The picture was adequate but far below the standard of a normal broadcast TV picture. Sound on very early cameras was mono. Editing was slow and laborious because cheap editing equipment was not yet available.

Today camcorders are widely owned and accessories to help you edit your video have fallen in price. The latest digital camera today costs 50% of the price of a 1984 camera – and of course the quality

of the images has improved ten-fold. You can now have equipment at home, which in 1985 even professional broadcasters would have envied!

Although many people now own video cameras, few people use them to their full potential. If you have ever shot video of children's parties or of your summer holiday – and then played your film back on the TV to show the family – you will know that once the novelty wears off, viewing your videos can be a bit of a chore to say the least! In time, some people even put the camera away; others lose or record over their master tapes. Even those who do transfer to a VHS tape are often not very impressed with the final results.

Having children is a great excuse to buy a video camera and is the main reason why many people do so. Those moments of baby's first steps or the ability to listen to how they used to speak can be captured and kept forever. Photographs capture just a moment in time, but videos allow you to relive those forgotten memories again and again.

When you buy a camera and after you have consulted the instruction manual, take the trouble to read this book, and those memories will be worth their weight in gold. Even better, those children will be able to show them to their own children and grandchildren!

David Lean, one of Britain's greatest film directors (*Oliver Twist*, *Bridge Over the River Kwai*, *Ryan's Daughter*, *Passage to India*),

started his career as a film editor. He could see the pictures in his head. He knew exactly which shot would cut to the next and why. The secret is to understand what you need to tell a story and how the narrative works effectively, before you shoot a frame.

You need not learn complex cinematography or directorial skills, but you should have a good fundamental knowledge of the basics. This book is a straightforward guide showing you how to plan, shoot and edit your videos. You will learn some basic shooting and editing techniques and you will be able to add music tracks and graphics to your video.

You can read about techniques such as composition, the choice of shot and how to get the best from your camera in different lighting conditions. Nothing technical – just a little bit of basic know-how and advance planning. Also included is a section on how to archive your precious videos.

If you would like to learn how to shoot and edit professional videos without extra expense, time or hassle, this is the book for you. Create videos that your friends and family will want to watch – rather than finding any chance to escape.

John Logie Baird would have been astounded to see how his creation is being used today, and although it all started with a dummy's head, the only limitation now is your imagination. Almost anything is possible!

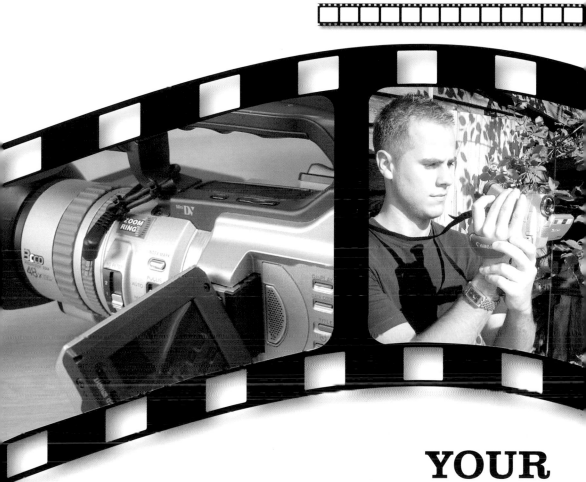

YOUR
EQUIPMENT

Camcorders

Cameras are available in every price range. To make professional home videos you do not need to spend large sums, but it is important to buy a good mid-range camera using the latest digital technology. This is because top-range video cameras have many extra features, most of which you will never use and some of which you should definitely not use. Cameras at the mid price range lack some of these features – and that is fine. Digital cameras produce high quality pictures – so there is no point in paying for added extras that you will not need. Find out what is available from the manufacturer's web site or printed literature.

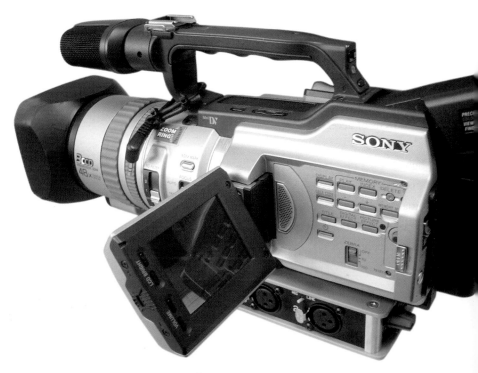

Accessories

The flexibility of camcorders has virtually wiped out the use of 8mm film for home use. The video image enters the lens to a CCD (charge coupled device) that converts the image into a series of electrical impulses that are then recorded on videotape. When played back the video's playing head converts these impulses back into an image.

Keep it light! Your camera & spare batteries should be kept in a camera bag. There are some circumstances in which a tripod or monopod is useful but few people carry a tripod about all the time and with practise your camera moves can look smooth, without the need of one.

There are dozens of accessories that you can purchase, such as filters, lights, microphones and remote controls. None of these are essential, however. The only extra that you will probably find necessary is a spare camera battery.

15

Here is a list of useful and not so useful added extras:

Operation Description	Use?	Reason
Auto Focus	Keeps the picture in focus in most conditions.	Usually. One thing less to concern yourself with.
Character Generator	To add titles.	Rarely. Add titles in post-production unless you intend to edit in the camera.
Date & Time	Shows date and time superimposed over picture.	Never. Only useful for *You've Been Framed!*
Digital Stills	Shoot still photographs.	Yes. Useful, but not essential. Better to use a digital stills camera.
Digital Zoom	Extends the range of the zoom using electronics.	Never. Very degraded pictures.
Exposure	Adjusts the amount of light entering the lens.	Yes. Use in some circumstances.
Fade button	Shot faded up from black or faded into black.	Never. Add fades in the edit.
Optical Zoom	Uses the camera optics.	Yes. Use sparingly in shot.
Image Stabiliser	Prevents camera shake.	Yes. Leave it on.
White Balance	Adjusts skin tone and colours.	Yes. Use in some circumstances.

There is a danger with any guide that it will quickly become out of date. At the time of writing, for example, there are six different camera formats available. However, most of the principles and information in this book will apply to any future format, and indeed, cine film enthusiasts employed similar rules and advice in years gone by.

Camera formats

Camcorder formats vary widely in price. These are the main ones available today, but there are several more using different tape formats. (See Chapter 3)

8mm low band

The cheapest is called 8mm, or low band. This was the first video camera format to be mass-produced for home use, long before the word 'camcorder' had been coined. In 1984 they sold for £1,000 upwards. Now they cost as little as £200. They were bulky and the picture quality was poor by today's standards; in particular, they did not perform well at low light levels. The batteries were large and often had a far shorter life than the camera itself. Although cameras using this early format are now much smaller and quite cheap, the picture quality is lower than digital cameras, so when you transfer to your finished video the quality is further degraded. Avoid these low band cameras if possible. It can also be difficult to obtain batteries and accessories and these cameras will be phased out in due course.

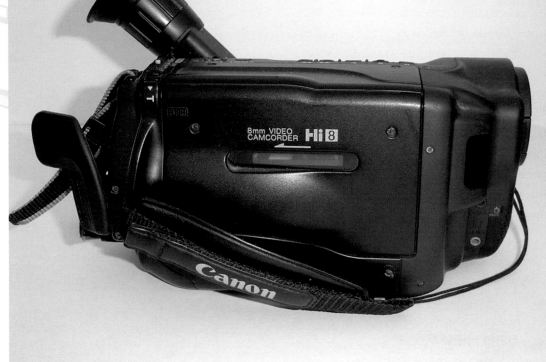

A 1995 model Hi8 camcorder.

Hi8 – high band

Next came Hi 8. These cameras are popular today and the picture resolution is very sharp. These are priced between £400 and £600. As with 8mm, if you transfer films to VHS the picture quality will drop markedly. If at some point you wish to upgrade to digital, you will always need to retain the camera to play the original tapes, unless you buy Digital 8, which uses the 8mm tapes (see page 20).

DV – digital video

Then came digital! These cameras can cost as little as £400 or as much as £3,000 for a semi-professional camera. An averagely priced camera will be around £600. Digital cameras produce first class images, but the real advantage is the ability to edit and copy with no loss of picture quality. The cameras are small, robust and some models can fit into a shirt pocket. Several models also capture stills, either onto the tape or on a separate memory card although few provide images as good as those from a high end digital stills camera. The quality of the image is measured in pixels – currently high end stills cameras use 5 million pixels whereas stills produced from most digital video cameras have under 1 million pixels.

The controls on a Mini DV camcorder.

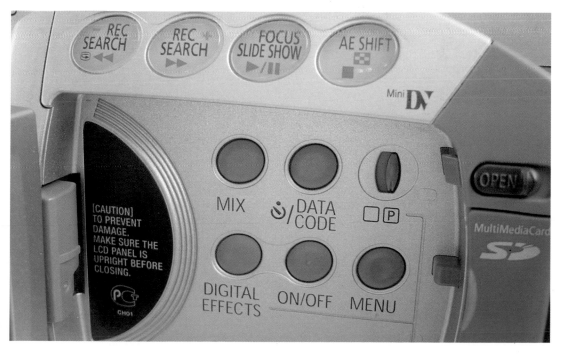

Digital cameras also use several recording formats. The most popular and versatile is Mini DV. These tapes are very small but produce stunning results. The alternative is Digital 8 that uses normal size 8mm cassettes to record onto. Whilst the next generation of cameras will record directly onto a small compact disc, a little like mini discs, digital cameras are likely to be around for many years to come.

Try to avoid purchasing a camera just before going on holiday. It's not a good idea to buy a new camera at the airport because you need time to familiarise yourself with the operation and shoot plenty of test footage. Do not buy a camcorder abroad unless you are very knowledgeable about differing TV systems, which are not always compatible. Many accessories, including mains leads, may not be suitable for the UK.

Chrominance	PAL	SECAM	NTSC	M-PAL
Scanning lines	625	625	525	525
Field frequency	50 EUROPE CHINA AUSTRALIA	50 FRANCE MIDDLE EAST	60 USA CANADA JAPAN	60 BRAZIL

Although Europe and Australia use 625 PAL, the two sound transmission systems are different – so do not be caught out!

Remember to take the instruction manual with you because on holiday, you will have time to experiment and may need help with some of the features you might not normally use.

Broadcast quality

Enthusiasts often ask why their pictures never seem as good as those they see each day on television. The answer to this is in two parts:

The main consideration is lighting. All studios and many locations are lit with powerful lamps, allowing the cameras to operate in the best possible conditions.

You also need to consider the camcorders themselves. Low- and mid-range cameras do not shoot at the same resolution as broadcast quality cameras. The most expensive camcorders operate using three chips, which represents a separate chip for each primary colour. Some of these more expensive cameras are now accepted as broadcast standard and cost between £2-3,000. Many TV shows such as *Changing Rooms* are shot using these light and portable cameras (illustrated below).

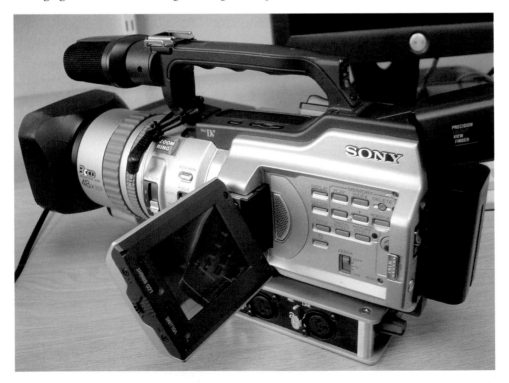

Protecting your camera

Your camera is an expensive and desirable item. Always keep the lens cap on when not being used. Protect it from the elements by ensuring that you always keep the camera bag with you. If it is raining, find a sheltered spot before shooting. Cameras do not react well to damp or wet conditions and bear in mind that this could also invalidate your guarantee. Always use the strap when carrying the camera bag – it's far too easy to drop or damage your camera if you don't.

Always take your camera on board aircraft as hand luggage - never put it in a suitcase or in the hold. Bags can be treated very roughly. Airport camera scanners do not normally damage either videotape or the camera itself.

Holding your camera

Kneel down to help keep the camera steady and level.

For maximum stability, grip the camera in your right hand and keep your elbow pressed against your body. Keep your feet apart. If necessary, support the camera with your left hand. With practice you will be able to operate the camera controls without taking your eye off the action. Ensure that your shots are rock steady and level. For tighter (zoomed in) shots, you will need to support either the camera or your elbows. Put your hand through the strap for added stability.

Keeping the camera and your shots steady and level is vitally important. You can steady yourself against a wall or a car. Try kneeling down and support the camera on your knee. Practise until you are happy with the results.

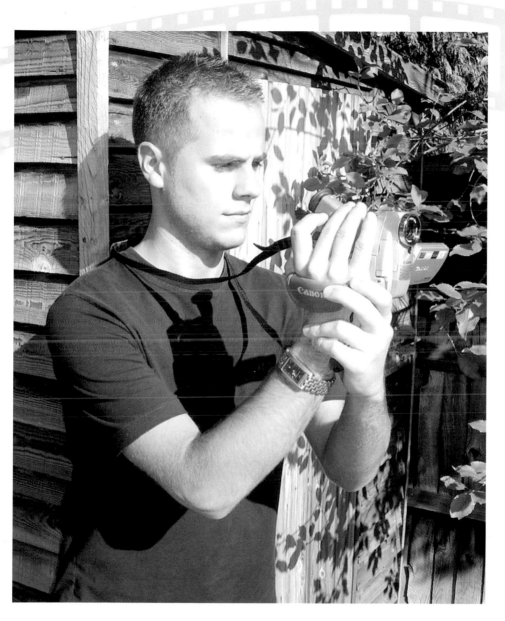

Lean against a solid object for stability.

Batteries

Batteries are expensive and have a limited life – so treat them well. There are several different types available, but whichever your camera uses, the basics are the same. Always charge up fully. Using a battery that is low in power can result in picture break-up. As soon as you get a 'change battery pack' warning, stop recording and change batteries or charge up. A fully charged battery will give you approximately 30 minutes of recording time but remember that some camera functions such as the zooming, rewinding and replay use power and will shorten the available recording time considerably.

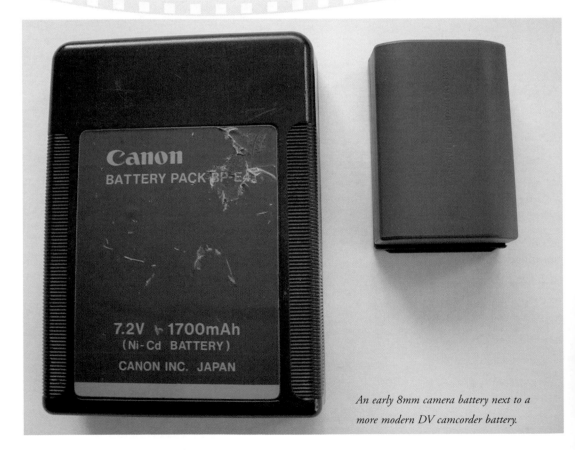

An early 8mm camera battery next to a more modern DV camcorder battery.

The most common batteries are as follows:

Lead acid

These are the batteries you find in your car. However, you might be surprised to learn that they are also used by film crews to power film and video cameras. They are cheap, give reliable output over a prolonged period and can be recharged many times over. They are also very robust and will last for many years. The obvious disadvantage is that they are heavy, cumbersome and do take a while to charge. They are not really suitable for camcorders unless shooting in one room or a static location for a prolonged period.

Nickel Cadmium (Ni Cad)

Ni Cads are lightweight and can be charged quickly; however, they do suffer from chemical memory. This means that if not charged fully, they remember that capacity charge which becomes the norm and very soon they will only hold a charge for a few minutes. If you constantly top them up when there is power in them, the chemical 'memory effect' will get worse. You are therefore recommended to fully charge and then fully discharge after each use. You can buy special discharging units for these batteries. When idle, they lose the charge fairly quickly. These are the batteries that powered the early 8mm video cameras.

Nickel Metal Hydride (NiMH)

These are similar to Ni Cads but they supply about 20% more power. As they sit idle they do not lose as much power as Ni Cads, but they do cost more and still suffer some memory effects.

Lithium-Ion

These modern batteries power notebook computers and nowadays most camcorders as well. They are lightweight and do not suffer from any memory problems, you can charge whenever you wish and the charge time is minimal. They are quite expensive, however – if you wish to buy spares they will cost £80 - £140.

You should remember that all batteries do wear out eventually and they will eventually reach a stage where they will no longer hold a charge. The cameras themselves are very reliable and it is normally the batteries that fail first. If your camera is more than a few years old, it can be difficult to obtain spares from the local high street. However, there are several distributors who can provide spares over the Internet. Either use a search engine to find them, or go to your local retail store and ask for details of their spares agent.

Battery belt

If you are likely to be shooting a very lengthy event, it is possible to buy or hire a battery belt. These batteries are external to the camera and consist of a number of batteries connected in series. You wear them around your waist and plug them into the AC power input in the camera. Check first that they are compatible with your type of camera.

Record modes

Cameras normally have several recording modes. These are sometimes known as long or extended play. In these modes the picture quality is lower so you should never use them. Always record in standard or normal play. The same applies to VCR and DVD recorders. Always record in the highest quality-recording mode.

Recording procedure

Having ensured that a tape is in the camera, and the battery is charged, switch to record pause:

- Remove the lens cap.

- Check the sun position and general lighting conditions.

- Flick the zoom to the widest position.

- Frame your subject carefully and adjust the zoom if necessary.

- If panning or tilting, check your finish and start positions.

- Frame your opening shot, and ensure that the camera is level.

- Release pause and start recording. Keep the camera steady.

- Do not hold the same shot for longer than six seconds.

- Stop recording and re-frame.

Filters

There is a wide range of filters available but you must purchase the correct type for your camera. Filters change the light entering the camera in differing ways and can also ensure a consistency to your video. There are many available but these are the most common and useful:

UV filter: Ultraviolet or clear filter. This essentially protects your lens from scratches and also against the unwanted effects of glare and haze of ultraviolet light. You will notice an improvement in picture quality.

ND filter: Neutral Density. When you are shooting in bright sunlight, an ND filter will help to reduce over-exposure by regulating the amount of light entering the camera, without affecting the colour. You will notice a far more balanced picture.

Polarising: A polar filter is like attaching a pair of very high quality sunglasses to your camera. It sharpens the clarity and reduces unwanted glare from reflective surface like water, glass, sand and ice.

Diffusing: A diffuser simulates a soft focus and is especially kind for faces. (Ageing Hollywood stars are particularly grateful!) It also reduces the harshness of raw video. A diffusing filter on its own can give your video a very subtle film look.

There are many others, including graduated filters which can add blue to the sky in the top of frame without affecting the rest of the frame. 'Star burst' filters can be useful to create star effects from any light source in the frame. However, in the interests of shooting 'clean' video as described later, you will generally only need the above four filters. Most of the others effects can be recreated in post-production. None of them are essential, but if you look at the before and after results, you will be suitably impressed.

Filters control the light entering the lens.

Camera colour balance

This is to ensure true colours and skin tones. Your camera will have a preset predetermined colour balance, but in some shooting conditions this can alter and the camera can become confused. Most cameras give you the ability to set the colour balance against white. To do this you use a white sheet of card or paper and set the balance while the camera focuses on it. If the white is correct, then the other colours, including skin tones, will be correct. You should not need this facility very often.

Viewfinder

Many cameras now come with both a viewfinder and a pull-out screen. The screen can be useful for obtaining some more unusual angles or for tracking shots when you need to be aware of the hazards around you.

Ensure that the viewfinder is focused for your eye. Within the viewfinder, a great deal of information is displayed. Learn what each of the symbols mean. Check your manual because it differs from camera to camera.

A 'hand' normally means that the image stabiliser is operative.
A 'battery' symbol will tell you how much power you have remaining.
An 'AF' symbol shows whether auto focus is selected.
The digital display will tell you how long the shot is recording.
A digital display of remaining tape time.
You will see a graphical representation of the position of the zoom.

You can also switch on 'data' information, which tells you the date and time of the recording and sometimes the aperture setting for each shot.

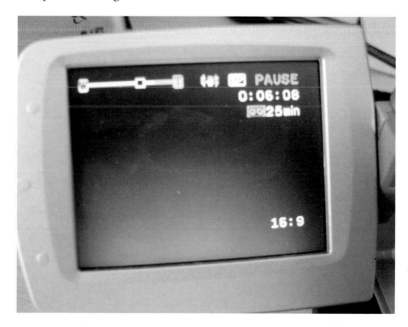

There is much useful information within the viewfinder.

Tripods and monopods

These are very useful in some situations but you are unlikely to want to carry a tripod around for every shoot, or indeed take one on holiday. A tripod gives you a secure base on which to place your camera. You can change the height from very low angle to about 6 feet or more and it allows you to pan the camera smoothly and to follow action without jerks. The best tripods have a fluid head that is a dampening mechanism. You can adjust this to aid pans and tilts by cutting friction to almost zero. A stable base is particularly necessary if you are zoomed in tight on a subject.

A monopod is a single leg which you need to hold upright, but it is very effective at keeping your camera steady and free from the shaking which can occur when hand-held. A monopod can also be used as a sound boom (pole). Monopods fold up into quite small items, so you might find them more convenient than a tripod.

Editing equipment

The advent of non-linear computer based editing has made professional editing available to all. However, some people still use the original methods that are described here.

Edit in camera

This is the term for editing as you shoot. Although fairly limiting, it can be effective and very time-efficient. You can still add music and voice-overs using the VCR audio dub facility. Even if you intend to edit, you should still be disciplined and think about the sequences as you shoot. Remember, for example, that the last shot was a wide pan of the swimming pool, so the next might be a close-up of the swimmer.

Using this system, you simply connect the camera to the input of your VCR, press record and play the finished tape out from the camera into your VCR. Nothing could be simpler. But when you play back, you might wish you had done it differently in which case you need an alternative solution.

Assembly editing

This is simply the term for playing the master tape out from the camera and re-recording the parts you wish to keep onto a VHS recorder. To use this method you will need a slightly more expensive four-head video recorder, also known as a flying head, which will allow you to create a smooth cut between your selected shots. You will also be able to change the order of your shots and their duration. (Flying head VHS recorders can be purchased in any good electrical retail store.)

To do this, you find the shot you want on your camera and stop the tape 3-4 seconds beforehand. Put the VHS recorder into record pause. Start the camera and, as the frame you want comes up, release recorder pause. Continue recording until just after the end of the selected shot. Find the next shot on the camera and repeat the process in this way. In order to obtain a smooth cut, the VHS will backspace. This means that it backspaces a few frames as you go into record. Bear this in mind when you line up the shot. You will slowly build up your edited video. It is quite time-consuming, but until the advent of computer-based editing, this was the most effective method.

Controls used for Assembly editing.

Once you have assembled your pictures in the right order, you can add music or commentary via an audio dub. This means using a spare audio track on the VHS tape to record music or a voice-over sound track. Even titles can be added by using a 'title generator,' a machine which allows you to superimpose titles on top of the picture in many differing styles, colours and fonts. The major disadvantage, however, is that you end up with one copy of the edited tape and each time you make another copy from it, the picture quality is further degraded.

Non-linear editing

Since the mid-1980s TV programmes and films have been edited using a non-linear digital computer-based format. This once expensive technology is now available to all; it is even a standard desktop application on many PCs and Macs which are usually shipped with video editing software already installed. Of course, there are many software packages available and you might want to upgrade to another, but they all work in a similar fashion. This is described in Chapter 10.

A computer workstation and monitor.

Hard drive storage

Moving images take up a large amount of hard drive storage which can be a limiting factor for home use, although the cost of storage is dropping rapidly. Five minutes of video takes up roughly 1 gigabyte of hard disk space. Additional hard drives can be added to most systems either as an internal or external drive.

If you computer is running slowly or your images are jerky, try defragmenting your drive. This reorders the information on it and frees up spare space. PC users can do this via the 'my computer' icon on the desktop.

- Press the C drive icon and right click on properties.
- Select tools and go to defragmenter.
- Ensure that all applications are closed before running.

Additional external hard drive storage.

Monitor

You will need a reasonably good quality colour monitor (TV) to work with and it is helpful to have a largish computer screen because you will want to see editing information at the same time. Your workstation can be multi-purpose so that the monitor and video can also be used to record TV programmes off air, as well as the output from your PC.

Sound

It is vital to have stereo sound output from your computer via loudspeakers. It is very uncomfortable to work for long periods of time wearing headphones, although you will need them to check particular sound edits and the sound balance at the review. You can buy cable-free headphones that run on batteries, which are very convenient to use.

Most PCs now come with sound cards and speakers which are normally of high enough quality for monitoring your sound.

Computer speakers can be used to monitor sound.

Connections and cables

Your camera will come with a few cables in order for you to connect it to a VCR and – if it takes digital stills - a cable and relevant software. However, you will need a number of additional cables. All equipment has clearly marked audio and video inputs and outputs. For editing, connect you video camera to your PC's inputs. Connect your VHS or DVD to your PC's outputs. Check your equipment and see what you require. The most common cables are:

Phono: These come in three cables connected together. The yellow is for video and the red and white for sound, one for each channel. Always connect the red-to-red and white-to-white. This ensures a consistent stereo left and right.

Scart: These plugs are video and sound combined. Most VHS and DVD players now come with scart sockets. These are normally 21 pin sockets.

Firewire: This is used to export digital video from camera to PC. It is one simple cable for both video and sound.

Identifying cable faults

A cable fault can cause a number of symptoms, such as no sound at all; sound which comes and goes, or low-level sound. There can be buzzing, humming, crackling, and increased pick up of mobile phone interference. If the sound comes and goes, wobbling the cable at the connector ends might show up the fault.

If in doubt, try replacing the faulty cable altogether.

Shooting ratio

This is a measure for comparing the amount of footage you actually shoot, with how much of it gets into your finished video. Whilst in theory you can shoot as much footage as you want, in order to be efficient and quicker in the editing process, you should ensure a reasonable shooting ratio.

Here is a comparison of some typical ratios. For example, a ratio of 10:1 means that for every 10 minutes of video shot, 1 minute appears in the finished cut video.

Feature films	60-100:1
Documentaries	60-80:1
TV drama	10-20:1
Home video	5-10:1

Documentaries have a high shooting ration because of the large amounts of film or video shot while waiting for something to happen. More than one camera is often used, and second or third cameras will hugely increase the ratio. Some large feature films will have between eight and twelve different units filming material for the same film.

Home video shooting ratio should be quite low because you are shooting actuality, events that are happening in front of you. You will rarely have multi-takes and a great deal of what you shoot should appear in the finished video, even though it may be heavily edited.

TAPES
AND TIMECODE

Tapes

Whatever you do, keep your original recordings (**masters**) safe and clearly marked. Never record over them, even when you have transferred, edited and completed your video. This is because one day you may wish to re-edit into a compilation, (see Chapter 14) or find unused sequences, and for this you will need to go back to the original masters.

Mark up both the tape and box clearly with as many details about the recording as possible. Particularly important is the date on which the recording was made. This seems like a chore – but in ten years time, with dozens and dozens of tapes, it will save a great deal of spooling time. Also keep a separate log of what each tape contains. This is very useful when you need to access material quickly for an edit.

Different tape formats

VHS (Video Home System): This was the system that began the home video revolution. The war was between Betamax and VHS. Betamax was, in fact, a very good format but VHS won the day because the tapes were smaller and more convenient. VHS has now been around longer than any other tape format. Some of the first camcorders used full-size VHS tapes to record on. Whilst they are still available, they are less convenient because the cameras are far larger. With the emergence of the increasingly popular DVD technology, VHS might have finally had its day .

S-VHS: This is a full-size format with resolution similar to that of Hi8, but is virtually out of the consumer camcorder arena. The format is still a strong player in the industrial market, but its future may be bleak with the release of newer and better digital formats. The 'S' stands for super, as the resolution increases from the VHS standard of 250 lines to around 400 lines. Unfortunately, most VCRs will not play a Super VHS tape and it has to be transferred to a regular VHS format in order for it to be viewed on non-S-VHS machines.

VHS/C: This was a system that allowed a smaller format tape to be played in an ordinary VHS machine by using a special cartridge. The tapes ran for 45 minutes.

8mm: 8mm camcorders often have many of the best features found in higher-priced Hi8 units, including image stabilisation, strong optical and digital zooms and innovative special effects. Regular 8mm tapes are the same size and shape as their Hi8 counterparts, but record video at a lower resolution level, and are therefore less expensive than camcorders that produce better image quality. 8mm has a resolution of 270 lines and this is known as low band.

Hi8: Hi8 camcorders record their signal at about 400 lines of resolution, slightly less than Mini DV, but substantially higher than 8mm or regular VHS formats. Most often, Hi8 camcorders record sound in hi-fi stereo. Slight quality loss is suffered when copying or editing from Hi8, but a better than average image is maintained. Tapes from Hi8 camcorders must generally be played using the camera as the source, which means the user must connect cables to their television or VCR. Hi8 tapes can be bought in 30-, 60-, and 120-minute lengths.

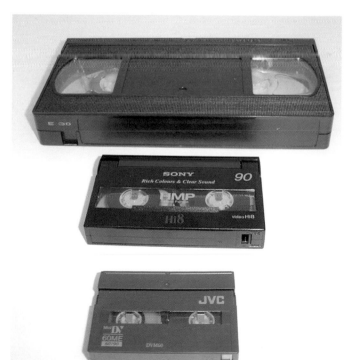

From top, a VHS tape, a 8mm and a mini DV tape.

Mini DV: These tapes are the smallest of all the video formats. They record and maintain crystal clear images. Editing enthusiasts benefit from Mini DV as well, since copying between two units is done with no quality loss. That means edited or copied video looks and sounds every bit as good as the original footage. Mini DV tapes are available in 30-, 60-, 63- and 80-minute lengths. Mini DV tapes can be transferred to VHS so you can watch them on a normal VHS/VCR (Video Cassette Recorder.) Digital camcorders have the highest resolution of all, starting at 500 lines.

DIGITAL 8: This is far superior to Hi8 or 8mm. It is backwardly compatible, meaning that the new Digital 8 camcorders and VCRs will also play 8mm and Hi8 tapes. You do not have to buy special tapes to record in Digital 8. A regular 8mm or Hi8 tape will record up to 60 minutes of digital video and audio, but it uses twice as much tape. So a two-hour Hi8 or 8mm tape will record 60 minutes in the digital mode at up to 500 lines of resolution. These camcorders are worth purchasing if you already have a large number of 8mm tapes.

Other broadcast standards

Betamax: This format was originally introduced by Sony in the 1980s, but was overtaken by the more compact VHS format. A few people still have Betamax machines, but they are now regarded as objects of curiosity.

Sony U Matic: Also known as "¾" videotape, this format was introduced in 1971 and it is still used by some people as it can produce good quality video; "¾" decks are still commonly available in duplicating houses. However, there is little reason for anybody to pursue this format given the technical advantages of some of the other more recent formats. It is slowly being replaced with digital equipment such as DV and Mini DV.

BetaCam: This was first introduced in 1982. It is currently geared for broadcast use, although there have been some less expensive models destined more for industrial use than for the home video market. Pictures from a BetaCam system (or other component format) will generally be markedly superior to those produced by any of the preceding formats. Colours, in particular, come out looking much more vibrant, and objects appear three-dimensional. The superiority of BetaCam comes partly from the technical aspects of the tape format, but also in large part because of the use of superior optics and other camcorder and VTR components

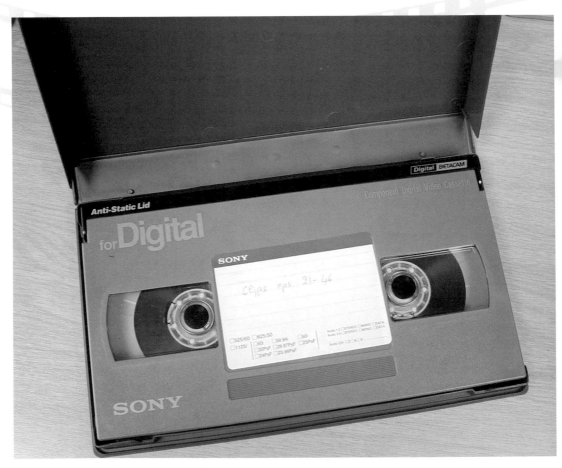

A Digibeta tape used by the broadcasters for transmission.

Digibeta: Broadcasters use digital betacam to transmit their programmes. The tapes are quite large and are likely to be partly superseded in the next year by computer file servers. Programmes will be played out directly from computers and archived on other servers, thus for the first time, eliminating tape entirely from the transmission chain.

The main home video standards:

- Standard VHS: analogue, low band. Bulky and heavy, picture poor by DV standards.

- Super VHS: better picture, Hi-Fi, high band. Cannot be played on low band equipment.

- VHS-C: analogue, low band. Needs adapter for VHS playback.

- Video 8mm: analogue, low band. Smaller tapes.

- Hi8: high band, excellent pictures. Pictures still degrade when copied, but backward compatible.

- Digital: excellent pictures and cameras are very small. No loss of quality when copied. 8mm or Mini DV tapes.

All of these choices can be overwhelming and for home video there will be more to come. Your main priorities should be price, picture quality and backward compatibility with your existing home videos.

If you do upgrade, for example from Hi8 to Mini DV, remember that these formats are not interchangeable, so you will need to keep a camera on which to play them. This is one reason why you should always buy the most up-to-date format if possible. Digital is the current format and Mini DV tapes are the most convenient. Just on the market however is the first High Definition camera for domestic use. It currently retails at £3,000. In a few years time this could be the new high-end camera!

Once the tape is full, slide the tab on the rear of the cassette to prevent accidental erasure. Any tape-based format will degrade over the years and these memories are precious. So store the tapes in a clean, dry environment and always in their boxes. Try to avoid unnecessary winding and rewinding. If you have logged the time code, this will allow you to find material on the tape quickly.

The security tag on the back of a tape.

Time code

Time code is the standard clock for video editing. In a normal clock you have 00:00:00 for hours, minutes, and seconds. Time code adds frames to the equation. So you have 03:23:11:12 = 3hours, 23minutes, 11 seconds, 12 frames.

The preview monitor showing the time code.

When you insert a new tape into the camera, the camera will start the time code at zero (00:00:00:00) and will count upwards. This will help you to find any material on the tape. However, if you leave a gap after your last recorded shot, the camera will think you have put in a new tape and will start at zero again. So if you have replayed the tape, or ejected it, avoid leaving gaps by starting new recordings just before the end of your last shot. The camera will then pick up the existing time code and continue from there. If possible, therefore, keep the tape in the camera until it is full.

Time code is important for editing because some software uses the time code recorded on the tape to mark your edit in and out points. It produces an edit decision list (EDL). This is the code that tells your computer how to cut the master pictures.

Check whether your software uses the time code on the videotape or creates its own when you digitise your material. The advantage of this latter system is that any gaps in the original time code are time-coded as you go.

Change the tape in the camera carefully and never on a windy beach! A grain of sand on the recording head can do permanent damage.

PLANNING AND STORYTELLING

Become familiar with your equipment. Read the instruction manual carefully; shoot some footage and practise editing it together. Like every other aspect of life, practise makes perfect. One of the challenges with home video is that many owners of cameras only use them occasionally, so they never really get a chance to improve. Once editing becomes second nature, your shooting will get better because you will know what is required to make better sequences.

Every video should be enjoyable to watch, so you should approach it as a story. Rather than just assembling some assorted, jumbled shots of Baby Rosie, for example, think about presenting the story of Baby Rosie's first six months.

The story of Rosie's first six months

Much of your shooting will be unstructured and shot as your holiday or family event unfolds; however, you can still approach it as a story with a beginning, a middle and an end. You will be shooting very much in story order. But this can be edited afterwards into any order you wish. The important point is to ensure that you capture all the shots that you might need in making an interesting and watchable video.

Exactly the same is true if you are shooting a short film and using a script or narrative. In this case you will be shooting out of order to make economic use of time and locations. Continuity is vital or you will have some nasty surprises in the editing. (See Chapter 8.)

Think particularly about the opening and closing sequences. A sense of place should be captured in the opening. Experiment with different ideas. If it does not work, it's not a problem; you may still be able to use parts to link a sequence together. For example, rather than just shoot a static view, start the shot against the trunk of a tree, then slowly pan from the tree to the view. Or shoot against a clear blue sky, perhaps allowing time to insert a title, then tilt down to the point of interest. If you later decide not to insert a title, just trim the hold off the beginning of the shot.

A useful shot to use in a montage.

You might think about a quick cut montage sequence somewhere in the video. For this you will need many shots and it is not a good idea to repeat shots too often. So, for a sequence lasting 60 seconds and each shot lasting three seconds, you will need 20 different shots. It is very common to return without enough shots to create this kind of sequence.

Never set the camera up somewhere in the room, zoom out to wide, press record and expect to capture all that happens in front of the lens while the battery lasts out! This is useless and furthermore cannot even be rescued by editing, as there is nothing to cut from and to.

Preparing your equipment

Ensure that the camera lens is clean. If necessary wipe with a soft dry cloth. Check that the batteries are fully charged and that the camera settings are correct. If the camera has settings for exteriors and interiors, ensure that you have the appropriate one set. Do a test shot, just a few seconds, and play the test back to ensure all is working properly.

Unlike film stock, tape is inexpensive so always carry spare tapes. Remember to take your battery charger and, if going abroad, a suitable adapter. Certain tape formats can be difficult to obtain in some resorts. Take care of your equipment and do not leave it lying around in hotel rooms. Either keep it with you, or make sure it is locked away out of sight.

Having prepared your equipment, take a few minutes to think about how to approach the video. Which extra shots might be useful later on? If attending a christening or a wedding for example, which is the best position from which to capture the key moments?

The storyboard within the editing software allows you to build up your shots in the correct order.

You will want to capture those special moments but you should also cover extra material (establishing shots) that you might need. A simple example of this for a holiday abroad would be a shot of an aircraft taxiing down the runway and a shot of a plane in the air. Whilst not directly relevant to your holiday, they are shots that could help bridge a sequence later on. Give yourself as wide a variety of shots as possible and of differing sizes and angles. Be disciplined in your shooting, but give yourself plenty of choice.

Gather establishing shots to make your video interesting.

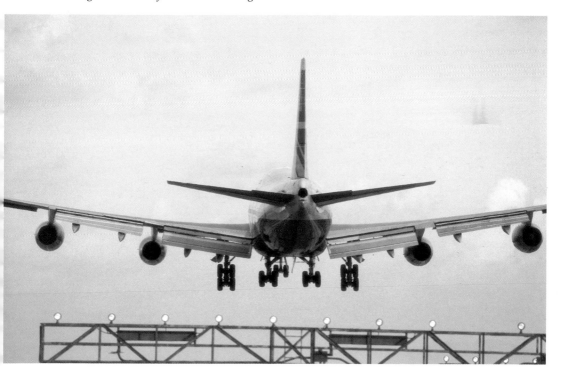

A selection of music CDs.

Remember that stories are not necessarily told in order. The most effective way to engage your audience is to begin at the end or in the middle with some exciting or interesting drama, then flashback to the beginning. There are many alternatives. A home video is more akin a TV documentary than a film or drama. Watch how documentaries are structured, how they are cut, the number of shots used, etc. Look at the use and placement of music.

You might already have some music tracks in mind before your shoot and you might be able to purchase some local music relevant to the time and place of your holiday.

You can think about titles and even make these in advance of your shoot.

Be imaginative and think of alternative ways to frame and compose shots. Here are some examples – but there are so many more:

- In the countryside. The subject is moving towards you. Begin on a tree trunk, filling the frame, hold then pan slowly to the subject. Once past, shoot them walking away.

- A group gets into a car. Start on the bonnet and move around as they get in; Shoot from the boot as car moves off into the distance.

- A group walk along. Get in among them and shoot walking along with them. A little bouncy cam can make the video feel lively. Use the pull-out screen.

- A couple are flamenco dancing. The man has a guitar. Keep recording and use zoom to alter shots. Get a close-up of her feet, of him playing, fingers on strings, a two-shot of them both, the crowd watching, her face, etc.

This is an alphabetical list of some techniques that you can use to improve your shooting skills:

SHOOTING
TECHNIQUES

Tip: If in doubt, shoot on the standard camera set-up, normally 4 x 3. If you are shooting in wide screen and editing on a normal television set, the pictures will appear squashed. But they will appear correctly for viewing in wide screen.

Aspect Ratio

Aspect ratio is a fancy word for the overall 'shape' of the picture. You have two formats available in most cameras. Wide screen is also known as 16 x 9. Use this if you will be viewing the final video on a wide-screen TV. Alternatively, if you are viewing on a standard 4 x 3 (14 x 9) ratio TV set, choose this option.

If you do shoot in wide-screen, remember that some people viewing your video may watch on a standard TV screen. This means that you should try to keep important action or titles away from the extreme edges of the frame, otherwise these could be cut off.

Backlight

Some cameras have a backlight button. A subject that is backlit will appear dark. The button simply increases the exposure allowing the background to burn out. This can also be done manually using the exposure button.

Tip: Experiment with this facility but use it sparingly.

Camera height

Most people hold the camera at their head height when recording but you can also shoot from a low position, – i.e. kneeling down - to a high shot, perhaps standing on a low wall. This will alter the effect of the shot considerably and make your video more interesting, but do not alter the height within the same sequence too often, unless for a particular effect.

If someone is sitting down, get down to his or her eye level.

Tip: Vary the height to make the video more interesting. For example if shooting a baby, get down onto the same level. Do not shoot everything from the position of the armchair. It will be boring.

Children

A camera is expensive and it is tempting to keep the children from using it, but it is better to teach them how to use it. Your children will always want to have a go at using the camera, particularly when new. Teach them how to use the camera and shoot simple sequences but do not let them go off alone.

Tip: Let them use the camera and become proficient. You may have a budding film director in the making.

Clean shots

Whatever gadgets you have available on your camera, you will not need most of them. Your recordings should be clean with no effects, slow motion, titles, fades, dates or anything else. All this can be added during the edit. Some cameras come with digital effects such as mosaic, sepia, and split screens. These can be switched on during playback so do not record with these switched on. If you do put it on while shooting, you are stuck with it forever and cannot change your mind later. The golden rule is to keep your options open and give yourself the maximum possible choice in the edit.

Tip: Ensure that the date bar code is switched off. You do not want this recorded in vision. Digital cameras log the date, time and even exposure information out of vision on the tape. You can access this later.

Crossing the line

This is something that all TV directors and camera operators have to understand, but like most rules, it can be broken in certain circumstances. Imagine two people sitting at a table. As we look at them, George sits on the left and Angela on the right. You can shoot any size shot, but it must be from the same side of the table. If you cross to the opposite side, George will appear on the right and Angela on the left. This will be very disconcerting to the audience if shown within a tightly shot sequence.

Tip: This is simply something to know. Do not let it put you off. Just be aware of it!

Tip: Remember - Always hold the shot for six seconds because you might wish to mix/ dissolve into or out of the shot.

Tip Another great way to signal a passage of time is to zoom slowly into your subject until the auto focus blurs out. Then begin the next shot blurred out and zoom back to reveal the subsequent scene

Cutaways

These are shots that can be captured at any time and will be useful in the edit. They will give you additional choices. For example, at a barbeque you might take a close-up of a sausage being put on the grill, or being turned over. You might use this between two other shots of people talking.

Effects shots

The creation of film and television is sometimes not what it seems. You can create many interesting shots before or after the event. For example by locking the camera position off exactly, you can easily make people and objects appear like magic in the same frame. By using various filters you can create atmosphere. There are also many different effects shot you can use at the edit, depending on your software.

Establishing shot

A shot showing the whole area in which the action will take place. It is used so that the audience can understand where the story is located.

These are like cutaways but are intended to give a sense of geography.

If you add a slow zoom to the shot, you could mix through to the next shot. You may alternatively wish to pace your video up and remove establishing shots. That is fine - but it's always worth having them, because they can act as a bridge between two shots, that if cut directly together, may look odd.

Always look for a landmark, a sign or natural monument that tells the audience where you are. For example, in films and TV series, you may see the camera zooming in on the Statue of Liberty, before cutting to a scene that happens within. Or a shot of the White House before the director cuts into a scene within the Oval Office. Another example, in *Friends,* is the exterior shot of the apartment block.

Tip: An interesting way to open a sequence of a dinner party or any large gathering, is to find a position before anybody arrives which gives a wide view. Then shoot an establishing shot for 10 seconds. When everybody is gathered, shoot another 10 seconds ensuring that you use the **exact same** camera position and height as the preceding shot.

When you edit, insert a 3 second transition between the two shots and you will have an effective mix where people just appear into the empty room or dining table.

Tip: You can make some limited changes to exposure in the edit, but it is best to get it right when shooting.

Exposure

Exposure is the term for how much light the camera's iris allows into the camera. Too much and the shot is over exposed, too little and it is under exposed. The amount of light in any situation is measured in 'lux.' Whilst your camera will deal with exposure automatically you will have several modes available which effectively alter the camera's iris to allow more or less light to enter the lens. Here are the average lux measurements:

Bright snow landscape	100,000
Bright summer day	40,000
Clear winter day	12,000
A dull day	4,000
An overcast day	3,000
Interior in bright daylight	1,000
Room at night	100
Candlelight less than	20

Most cameras will have an automatic exposure. The camera will expose automatically for the conditions it finds. However, there will be occasions when you will want to adjust it. (Check your cameras settings for sports, portrait, sand and snow, etc.)

Eyelines

The subject's eyelines are vitally important in making sense of the shots and ensuring that they cut together comfortably. For example, if a person standing up is talking to a person sitting down, you need to shoot the person standing up from the low position of the person sitting, otherwise the shots will not cut together. For two people sitting at a table, you need to ensure that the angle and height of the two matching shots are similar.

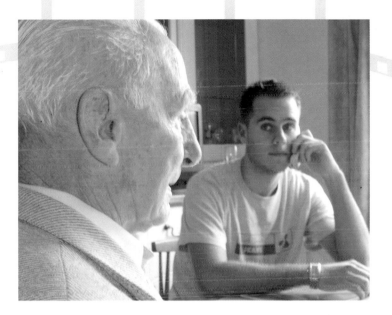

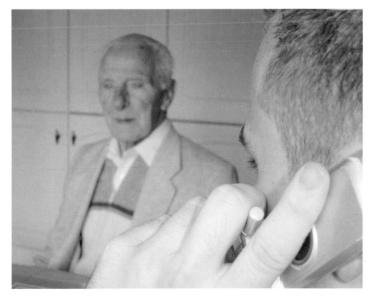

Focus

Focus is about more than just keeping your image sharp. It also allows you to split focus between the foreground and background. This difference is called the 'depth of field'.

Focus is automatic on most cameras now, and a professional cameraperson will always switch this off and adjust focus manually. You might want to create some effects by deliberately softening the focus-when filming the lights on a Christmas tree, for example.

Auto focus will sometimes focus on the wrong aspect, such as the foreground tree and the subject of the shot goes soft (out of focus) Sometimes the auto focus will 'hunt' the wrong subject while you are shooting, which makes the shot soft for a second or two. Using manual focus will avoid this, but it can take some practise to ensure your shots remain in focus.

Some subjects are unsuitable for auto focus:
- horizontal stripes
- many subjects at differing distances
- behind glass
- without much contrast, i.e. a white wall
- reflective surfaces
- fast-moving objects
- dark subjects
- night scenes.

For the most part, automatic focus ensures that your video is sharp and clear. However, consider using manual focus in instances where there's practically no contrast between subject and background, and the camcorder isn't sure what to focus on. Shooting a snowman that the children have built against a snowy landscape is an excellent example. To the camcorder, the whole scene looks remarkably similar and its circuitry can't decide where to focus, so you should identify the subject and focus for the camera.

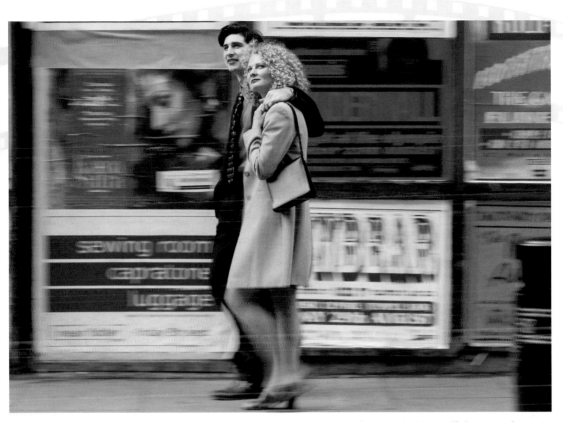

Hold your foreground subject sharply in focus.

As you become more practised, try switching off the auto focus. Switching from automatic to manual focusing modes is different on each camcorder, but generally this is accomplished by choosing a setting from your camcorder's on-screen menus or by pushing a button or two on its controls. (Refer to the manual for more information.)

Focusing manually is useful in a number of instances. It can be used to compensate for delays in automatic focus when performing a fast zoom. While it's best to keep zooms to a minimum and use them sparingly to add a dramatic effect to a video, here's the trick to using manual focus when zooming. First,

turn on the camcorder's manual focus mode. Without recording, zoom in on the final point of the zoom – the location of the tightest shot after the zoom is completed. Focus on this spot using the manual controls so that it's sharp. Now, zoom out to the point where you want to begin the zoom. Notice how the picture remains in focus. When you start recording, your picture will stay sharp from its widest to its tightest shot as you zoom in.

Shooting at the zoo is another excellent example. In this instance, you might be trying to shoot an animal that's in a cage. When you point the camcorder at the cage, it doesn't know whether you want it to focus on the bars of the cage or on the animal that lives inside. Because the dark bars of the cage often have more contrast against the lighted background than the animal in the cage, the camcorder generally focuses on the bars instead of the animal so the bars are sharp and the animal isn't. You can make sure that the focus is on the animal by turning off the automatic focus feature and using the manual controls to set the focus yourself.

Tip: Begin a shot out of focus and slowly bring into sharp focus. This will work well with a music track.

Follow focus

A follow focus is actually a piece of equipment that allows the focus puller to keep a subject in focus through a long distance. You can do a similar thing with your camcorder. Try the shot using auto focus; it may work depending on the type of shot. If not, put into manual focus and practise a couple of times before shooting. If you cannot hold focus over such a long distance, then you will need to consider breaking the shot up into several parts and shooting each one, over a shorter distance. The tighter (closer) the shot, the more difficult it will be to hold focus over a long distance. A tripod will be essential in this case.

Framing & composition

Good composition is as important in video production as it is in still photography. Some people are natural at it – but there are some very basic rules. The picture in the frame should look comfortable and well-balanced.

Tip: Rather than just get a shot of a watermill, give the frame some foreground by using a tree or part of an overhanging branch.

When framing your subject you have to balance the requirement to be in as close as possible to the subject, eliminating uninteresting backgrounds, but at the same time allowing for movement.

Tip: There are very few occasions when you should frame dead centre, except of course Newsreaders!

Position subjects slightly set to one side of the frame. If shooting widescreen, frame slightly to one side with some background. You can create depth by framing the foreground person at the waist, off set slightly to one side with the background clearly stated behind.

Interview techniques

In some videos, interviews form the centrepiece. Whether exterior or interior, you will need a person to operate the camera and a person to ask the questions and possibly appear in vision. Sound is important so use a clip mike, desk mike or a hand-held mike. (see Chapter 9) You can position the camera either just above or below the subject's head. Shooting from below can appear to increase their authority. Shoot from above to give their words less weight. You should not mix the heights in the same interview.

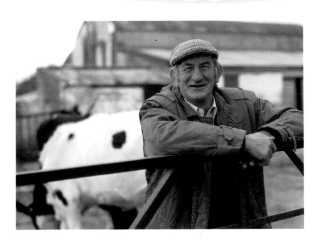

Questions: Let the interviewee know beforehand the kind of questions you will be asking. However, do not give them the specific questions, as this may ruin the spontaneity of the interview.

Establisher: Before you begin the main interview, shoot ten or fifteen seconds from behind the interviewer. Show them both in the same shot in order to establish the relationship. Just ask them to chat together while shooting.

Cut-ins: Very similar to cutaways (see page 74), these are usually close-ups of hands clenched or playing with a pencil, for example. They can be used to bridge other shots and can also convey something about the subject, i.e. nervousness, stress.

Noddy shots: After the interview, once your interviewee has left, re-record the interview with the interviewer asking the questions and pretending to listen to the reply and reacting, nodding or laughing, depending on the content of the interview. You can then cut these into the interview at the appropriate moments.

Lenses

A film camera is different to a camcorder in that it is just a camera body. Lenses have to be attached and are changed depending on the shot required. A distagon lens is a very high quality fixed lens that comes in the many focal lengths required from 6mm to 180mm or more. DOPs (Director of Photography) favour these lenses because they allow the maximum amount of light through to the negative. Alternatively, a zoom lens can be used. This gives greater flexibility and speed of use in some circumstances. The quality of the lens is one of the main factors in the quality of the image.

Tip: It is vital to protect the lens by using a UV filter (see page 30) and occasionally wipe over with a soft dry cloth

A camcorder incorporates a fixed zoom lens that allows a fixed amount of light to enter the camera. Unlike stills cameras, you cannot change the lens.

Limit camera movements

Tip: Keep any camera movements minimal and very slow and smooth so that your audience hardly notices. A moving camera combined with a moving subject can be disorientating to watch. The camera should be invisible, only your subject should attract attention.

This is probably the single-most important aspect to improving videos. Just because you own a mobile phone, it does not mean that you have to walk around constantly while using it, although some people do! A camcorder is small and it is tempting to move it and jerk it around constantly, which is why home videos have such a poor reputation.

Looking room

Tip: It's not a news bulletin! If someone is talking to camera, frame then slightly left or right and let the viewer see the background.

Unlike huge cinema screens, TV screens are smaller and more intimate. The most effective shots on television are tighter shots. But to make an effective video you will need a good selection of different-sized shots. For shots of people, the MCU (medium close-up) is most effective. This is basically head and shoulders. If two people are talking to each other, when you shoot a single shot of each person, the one on the left should be framed left of centre, the same with the other person right of centre. This is called 'looking room' and when you edit the two single shots together; it will look far more comfortable than if both were framed in the centre.

Subject framed left with looking room.

Subject framed right with looking room.

Low light

Most cameras have the ability to record in low light. The shutter speed is fixed at a slow speed. It is generally best used for close-ups of slow or stationary subjects because moving images may leave a trailing after image. However, you can take advantage of this to create special effects by rapidly zooming or by panning along with a moving object. Picture quality will not be as good as in normal lighting conditions and the auto focus control will not work as well as normal.

Matching shots

Keep in mind 'crossing the line' (page 73). Most conversations between two people require a minimum of three shots. The first is the establishing shot of the two people framed from the front with some background. The second is over the shoulder of one looking at the face of the other and the third, known as the reverse, over the shoulder of the other person. Additional shots of different sizes can be added, but they must all be from the same side of the line.

Moving subjects

Try to begin the shot just in front of the moving object. For example, say you were filming a boat. Allow it to glide into frame, pan gently with it for a few seconds, then gently stop the pan and let the boat glide out of your frame. Keep an eye on 'direction of travel'.

Tip: Remember to hold the empty frame for six seconds. This allows you to mix into or out of the shot in the edit or even to use the empty frame in its own right

Night

If you have a night programme it automatically adjusts the shutter speed. It is useful for shooting at night if you cannot get lamps in and there is little available light. The picture quality will be poor.

Panning shots
3 shots in 1

A camera pan is a slow, steady move through an arc from one point of interest to another. For example, the shot begins on a rooftop and pans down to a swimming pool. If done properly you get three possible shots in one. (A single shot of the roof, the entire pan itself, and a shot of the pool). Start on the end frame. Practise making sure that the swimming pool is framed correctly and is the right size in the shot. Move to the starting frame and practice the slow pan down to the pool. Most pans are slow. The alternative is a whip pan that is usually done for effect. This is a very fast, blurred pan and is used sometimes to indicate a passage of time or a move to a different location. A pan will look comfortable if there is a motivation for the move. Although not always possible, if you can use someone walking across or a car driving in the same direction as the pan - it will appear very natural.

Tip: Frame the opening shot of roof, press record, hold steady and count to six, pan gently to the pool, once settled, count to six and stop recording. This long hold at each end of the pan allows

both shots to be used in their own right, without the pan. It also allows enough time to mix through from an alternative shot in the edit.

This is the camera's POV.

Picture perspective

Find imaginative ways to change the angle or perspective. Shoot from behind the subject or from above. You can even shoot walking up the steps and opening a door before reaching your subject. Watch make-over programmes on TV and see how it is done. Shots are planned and rehearsed. It may look spontaneous – but it's not!

Tip: Look out for opportunities. For example, a group of your friends at a hotel reception leaving the hotel for a day out. Leave ahead of the group and obtain a group shot coming out of the hotel.

Pan round as they walk past and hold the shot for six seconds. This can be edited into two separate shots or used with the pan. See how it works later.

Points of View (POV)

These are shots of what a subject or character sees. Also known as POV, they should be taken from the subject's position although you can cheat distances using the zoom. Camera height is very important. Unless you're shooting a reflection in a mirror, the person who's point of view it is, can never be seen in shot.

Tip: A shot such as the image below, taken from behind a subject with their shoulder or head in frame, cannot be their POV and is not,

Tip: Use this with the late afternoon sun behind you. Your subject will be very flattered with the result!

Portrait

Most cameras have different settings. Portrait can be used outdoors to make subjects stand out from a softened foreground and background. It works well for still life and close-ups. The effect is most noticeable when the zoom position is mid-way. Focus manually for maximum accuracy and be careful if recording fast action scenes as this programme may cause fast moving objects to judder.

Right: Use the portrait setting on your camcorder, which makes the foreground sharp, with the background in soft focus.

Pull or throw focus

When shooting some scenes, there may be a number of aspects of interest. For example, a presenter, close to camera, may be talking about a castle in the background. As the presenter turns round, we alter (pull) the focus so that the castle in the background becomes sharp and the presenter becomes soft (out of focus). This technique is powerful because it takes your eye immediately to the aspect that you want the viewer to see. This is often used to introduce a scene

Tip: If you intend to pull focus, practise a few times before you record.

Reaction shots

Above: Take time to film your subject giving the desired reaction.

These are shots of people nodding or reacting to an event and can be used to cut into a sequence to give you more options in the edit. Of course, for interviews, people will be asked to give a particular reaction. You can get similar reactions sometimes by shooting the person listening, rather than talking.

Tip: If shooting a conversation, keep the camera running and pan slowly from person to person. Alter the size of shot from time to time using the zoom or by moving around the group with the camera.

You can often see this done on TV and with some editing, you can make an effective sequence.

Tip: You can buy portable units on which to play and wind your tapes. For mini DVs these cost around £900.

Rewinding

Avoid unnecessary winding and rewinding of the tape in the camera. This can cause wear to the recording heads and eventually result in poor picture quality. Once recorded, you simply need to rewind once to the beginning of your time code and then play out once to the computer and your tape is then lined up for the next shoot.

Below: A mini DV recorder and player.

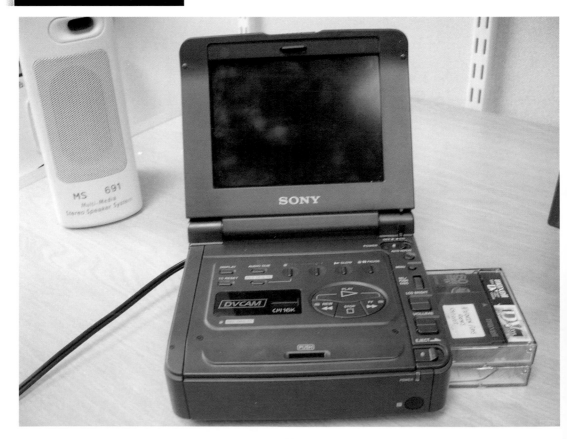

Rostrum work

A rostrum camera is one that is held secure in a frame, and points vertically downward. This is used for animation work and for shooting any static objects such as books, maps, slides, etc. These cameras are being used less and less, because much is available on PCs and it is now easy to do a screen capture and then cut this into your video directly. It is still useful, however, for some items, like a book with a page turn, or if you want to put some camera movement into the shot. A rostrum camera can also pan, tilt and zoom.

Tip: A slow zoom into a map showing a place name then a dissolve into the place itself can be a very effective beginning to a video.

For home video you will be able to use your tripod to create a rostrum camera. Most tripods will allow the camera to be turned into the required vertical position. You will need a secure, flat surface underneath and two lamps positioned either side of the tripod. The lamps should have the same wattage bulb and if possible a daylight bulb, available from art shops. All camera movements will have to be very slow and smooth.

This system is suitable for filming:

- Postcards
- Paintings
- Photographs
- Maps
- Charts
- Newspapers
- Books
- Greeting cards
- Diagrams.

Same direction

This is a simple concept that requires you to keep the action happening in the same direction – left to right, or right to left – but not both. For example, let's say that your subject is walking around the block. You are waiting at the end of the street as he approaches you. He goes past your left hand side – camera left. In the next shot of him, he needs to come from the same side otherwise, if he comes from the right, it will appear as thought he has changed direction somewhere.

These two images are different angles on the same piece of action, but show the subjects walking in the same direction.

Shot length

Although you will alter the shot length in the edit, ensure that during recording, you hold it long enough. Hold it for a minimum of six seconds. Do not cover masses of unwanted material, though. Instead, either zoom into a different size shot or stop, reframe and continue recording. This will allow you to edit differing size shots together into a sequence.

If you simply shoot a series of wide-angle group shots of a birthday party for example, it will be impossible to edit (cut) together and very, very tedious to watch.

You may want to use any shot to mix through to another or as an opening or closing shot with a fade to or from black. Never use the fade button in the camera. Everything can be shortened in the edit but it cannot be lengthened. For example, if you have a six-second shot and you decide to add a three-second fade from black, only three seconds of the shot will be left which may not be enough for your purposes. Always shoot long if possible.

Tip: For viewing on TV, close shots are the most effective. Get a shot of a balloon, birthday cake, young Rosie covered in chocolate, guests arriving, and opening presents. Obtain lots of different size shots. You will need a surprising number, particularly in a fast cut sequence.

Right: Hold the shot for a minimum of six seconds to allow for editing.

Shot size:

There are many different shot sizes and you will need to know when to use them and how to cut them together. These are the main ones.

EBC/U Extra Big Close-Up. Focuses on minute detail. Creates a sense of mystery and surprise.

BC/U Big Close-Up, showing just eyes, or mouth. Shock effect.

C/UP Close-Up. A close shot which shows most of the face. The top of the frame will cut at the forehead and the bottom, just under the mouth or chin. Use this to make a big point. Reveals character and feelings.

MCU Medium Close-Up. Standard news interview shot. It cuts off at around the chest. A very effective close shot for the small screen.

M/S Mid Shot. From top of head - cuts off at the waist. It is a good shot to introduce people to your audience. You get a good image of the subject and their surroundings.

L/S Long Shot. Takes in the whole height of the person Master or establishing shot

V/L Very Long. Panoramic shot. Conveys sense of isolation

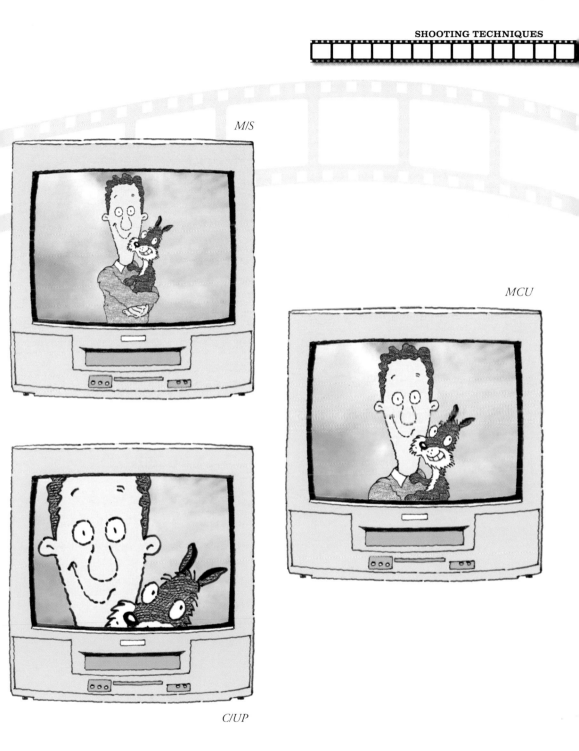

M/S

MCU

C/UP

Safety first

Safety is a major consideration in television and video production. This is because it is very easy to become distracted with the view through the camera and the famous words 'back a bit' could spell disaster! There are many other hazards to bear in mind as well:

- Never shoot in dangerous locations such as on main roads or at the edge of cliffs.

- Always look where you are going, beware of kerbs, lampposts, holes in pavements, etc.

- Never drive and attempt to shoot at the same time.

- If using chairs or ladders, ensure they are secure and if possible, get someone to hold onto the base.

- Tape any leads to the floor with masking tape, to prevent people tripping up.

- If abroad, take care where you shoot. Some countries do not allow filming in airports or military areas. Your kit could be confiscated or you could even be arrested.

- Do not use lights, particularly at night unless you have done the relevant lighting courses.

- If shooting at night, wear high visibility clothing.

Sand and snow

Use this setting in places where the background is so bright that
the subjects appear underexposed in the monitor – a sunny beach
or a ski resort, for example. You may notice some shudder when
recording moving objects.

Seascapes

You can capture a wealth of different shots of the sea at different times of the day and in varied weather condition. In the late afternoon the sun sparkles on the surface of the sea. Zoom in close to obtain a shot that can be used in titles.

Early morning horizon shots can also be useful.

Shooting indoors

As with cine cameras, camcorders produce the best results outside in good balanced light. Cinematography was pioneered in California and with good reason – it is sunny for 16 hours each day! Hollywood was within easy reach of Los Angeles with every type of background and location, on the doorstep.

As the phrase 'home video' suggests, many people use their cameras in the home, where light is often poor. Manufacturers have added enhancements to cameras such as 'poor light' or 'night light' settings. Although the cameras do perform reasonably well in these conditions, the resulting video will be darker and may have more noise or sparkle (grainy picture).

Tip: Shoot with your back to light sources, windows, etc. Raise the camera exposure a little if necessary. You can also purchase a photoflood bulb that will raise the light to an acceptable level. But best results are always achieved outside.

If you shoot inside towards a light source such as a window, the foreground will be very dark.

Sports

This setting is useful for recording high-speed sports scenes in brightly lit conditions. Normal playback will be slightly jerky, but you will get clear images that can be analysed frame by frame during slow or paused playback.

Stock shots

It is worth building up a small library of stock shots. These are shots that you can use in any video, such as sunsets, seascapes and general non-specific shots.

Subjects

Ideally, you want to shoot scenes of your subjects naturally, without them being aware of the camera. This is easier said than done. Some people hate being filmed and turn away, others act up for the camera, and few can ignore it. However, in time people do get used to it and it is possible to shoot natural conversations.

Subjects who ignore the camera will give the best results.

Tip: Most cameras have a small red light on the front, called a tally light that illuminates when the camera is in record mode. This light can be switched off so it becomes impossible for your subjects to know when you are shooting.

Tip: Holding the camera high over your head with the screen pointing down can be effective to get above a crowd. You can also turn the screen right around so that your subject can see the recording.

Tilting shots

These are like panning shots, but instead of a horizontal left to right or right to left, tilting shots are in the vertical plane, up and down. So for example you may be tilting down from the top of a building to the fountain at the bottom. The same rules that apply to a panning shot are also useful for a tilt in order to allow yourself the possibility of using both ends of the shot separately, or the entire shot if you wish.

A tilt shot is similar to a panning shot, but you film in the vertical, rather than horizontal, plane.

Title shots

As you shoot your video, think about special shots that you might want to edit together, perhaps with music, to create an opening title sequence. You can shoot them at any point as the occasion arises.

Tip: Look out for sunsets, seascapes and cloud formations that can all be used to create effective title sequences. Shoot from aircraft or other vehicles. Keep your camera handy and charged!

Tracking

Tip: If you want a shot of yourself walking along, check that the zoom is as wide as possible. Turn the screen right around; hold the camera at arms length, slightly higher than

your shoulder in record mode and point at yourself. You will see this shot sometimes used in documentaries.

Tracking is similar to a pan, but instead of moving the camera through an arc from a static position, the whole camera moves. This is very effective and can add style to your video. On a feature film, a 'railway track' will be laid by the grips so that the camera dolly can smoothly track along. This would be used, for example, to follow two people walking. On a cheaper production, the camera operator might be wheeled along in a wheelchair if the floor is smooth enough.

For the purposes of your video, use the pull out screen and simply walk along following the action. You can follow your subject from behind, in front or track along the side parallel to them – but be very careful if walking backwards! Most cameras now have a lens image stabilising system that keeps the action very smooth. Keep this switched on.

Underwater

You can buy watertight camera containers that allow you to shoot underwater. These are available for most models. Hard cases are more expensive than the lightweight ones, but the hard cases allow greater depth. Consider taking your camcorder into the sea only with watertight protection. In most cases, though, underwater filming is specialist work and best left to the professionals.

Tip: Some approved diving schools will shoot video for you and sell you a tape. You can convert this to a digital format and cut this into your own video.

Windows and doorways

Be very careful about shooting subjects backed by windows or bright doorways. As noted earlier, cameras do not handle the contrast between interior and exterior very well. The camera will expose for the bright light coming through the window and leave your subject inside the room very dim. The shot can sometimes be almost unusable.

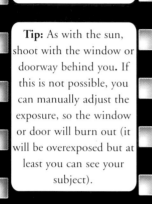

Tip: As with the sun, shoot with the window or doorway behind you. If this is not possible, you can manually adjust the exposure, so the window or door will burn out (it will be overexposed but at least you can see your subject).

Zoom

The zoom allows you to alter the size of the shot without physically moving. Apart from some special situations, you should use the zoom sparingly whilst on shot. Some cameras add to the length of zoom by using a digital zoom. Avoid this at all costs because the picture is severely degraded. Sometimes a slow zoom can be very effective. Always try to inject some slight movement of either the camera or subject into the shot, otherwise you will end up with static photographs!

Tip: Practise zooming as slowly as the camera will allow. A fast zoom (crash zoom) is only used for zany effects or for changing the size of shot. If you use the zoom while recording to reframe, you can edit out the zoom later on.

Use the zoom to change the frame size, but do not over-use it.

LIGHTING

When shooting video you will most likely use 'available light.' This means, whether shooting indoors or outdoors, that you make the most of whatever light is available. Modern cameras perform very well in poor light but there are some circumstances in which you might need to supplement the available light.

A good use of light and shade.

Choose a location with a good amount of available light. Perhaps this is coming from a well-lit interior, or else through a window, in which case ensure that your subject is facing the light source. Be aware of which way the light is falling.

Exteriors

When shooting outdoors it is important to understand the lighting conditions. Check on the sun's position. Are there areas of shade? Bright sunlight can be an effective way of lighting your subject but it does have drawbacks; it creates bright highlights and dense shadows that the camera finds it difficult to deal with. The bright highlights become bleached out and the shadows become black voids with little detail.

A cloudy day can produce a result that is a little colder, or bluer, but a more balanced light so these are better conditions for shooting. On a professional shoot, the director of photography will light the shadows to lessen the contrast. This is why you often see large lamps being used on exteriors. On a sunny day a simple piece of polystyrene about 4ft by 4ft can be used to reflect the sun onto a face or a subject in shadow.

'God's key light' – the sun!

Tip: The general photography rule holds true for video, too. Keep the sun behind your left or right shoulder so that the light falls onto the subject. Take care not to shoot your shadow. The same applies if the sun is behind clouds.

Always know where your light source is.

A key light means the main lighting source. For best results, avoid shooting exteriors around the middle of the day. This is because the sun will be overhead giving few shadows and little relief, resulting in pictures that can appear flat and colourless. In the late afternoon or early morning you will have good definition and a wonderful orange texture in the light. This is because the higher the colour temperature, the bluer the light. The sun is at its strongest at midday. Never point the lens directly into the sun as this could damage the camera, but you can try shooting in the direction of the sun. This will often give you strobe and 'star' effects that can be used for titles and will often help to help stylise your video. You can obtain filters to create a similar effect.

A sunburst effect without filter, shooting towards the sun.

Interiors

If possible, try to avoid shooting interiors at night. However, if you do wish to add light to an indoor scene, never use a lamp attached to the camera, pointing straight at your subject. This will make them look as if they are under interrogation! Instead there are a number of lighting solutions.

Bounce light

Use instead what is known as a 'bounce' light which will increase the light level and create a softer light instead of hard shadows. To do this, simply point your lamp at a wall or a reflective surface close to the subject. This is known as a soft light and is the most effective for producing a natural effect.

You can also use a large piece of polystyrene to reflect the light towards the subject. Lighting for film and TV is a specialist area that requires the correct lamps that are usually operated by the chief electrician (gaffer) and his team of electricians.

Right: When filming interiors use lamps to 'bounce' light on to your subjects.

When lighting interiors using one lamp, there are several positions and effects to be aware of:

Under light

A light in front of the subject but at a lower level, lit from below, creates an eerie or supernatural effect. See below!

Halo light

A light behind the subject lights the hair but the face remains dark. You can adjust this with a front lamp.

Understanding colour temperature

Every single light source, from the sun to your bedside lamp, emits a slightly different colour. This is called the colour temperature, and it is measured in degrees on the Kelvin scale. This colour has a big impact on the overall colour of your videos so it is important to understand it and to know how to affect it, if you wish. For example, let's say that you are wearing a white shirt. If you compare footage of that shirt shot both outside and indoors, you would notice a different shade of white. The human eye compensates for this difference unlike the camera. On the Kelvin scale, light sources with a higher colour temperature have a bluish quality, while the lower ones are orange.

Light sources	Colour temperature in °K
Clear blue bright sky	10,000 to 15,000
Cloudy sky	6,000 to 8,000
Noon sun	6,500
Average sunlight	5,400 to 6,000
Electronic flash	5,400 to 6,000
Household lighting	2,500 to 3,000
200-watt bulb	2,980
100-watt bulb	2,900
75-watt bulb	2,820
60-watt bulb	2,800
40-watt bulb	2,650
Candle flame	1,200 to 1,500

Some cameras provide a filter to use under certain lighting conditions. If you use this incorrectly the results will be very obvious. From the above table you can see why home video shot indoors under a standard 100-watt bulb will look rather orange compared to your exterior footage.

Colour grading/ matching

Broadcasters use expensive equipment to colour-correct scenes to match each other. Scenes shot in a studio will look orange, while those shot outdoors will be blue. This is called grading. However, for home use this is only available on the higher end editing software, so just try to use the tips provided here to ensure a better colour balance during your shoot.

Shooting at night

Modern cameras allow you to shoot at night. Be aware that the picture noise (graininess) will increase greatly. Lighting is obviously possible and lighting courses are available for those interested in lighting their videos properly. Directors of photography for film and television will always try to find a natural light source, such as the moon or a street light, and then supplement it by adding a considerable amount of light, sometimes using lighting platforms to raise their lamps to the correct heights so that shadows appear in the right place.

SHOOTING YOUR VIDEOS

Most people buy video cameras in order to record and preserve the most important events of their lives as they unfold. Whatever the event, whether a wedding, holiday, birthday party or christening, camcorders are capable of preserving these occasions long after memories have misted over and only a vague impression is left.

Before the video generation, people used to record some of these events on 8mm film. Today these old films can be transferred to video or DVD, usually by specialist companies that advertise this service. 8mm film enthusiasts had to be extremely disciplined in their shooting because film stock was fairly expensive and the films were usually shown in the order they were shot, without any editing.

Today, video gives us total flexibility to shoot as much as we want and then to manipulate those images into any order and enhance them with music and effects. Nevertheless, it is still important to have some basic knowledge of the subject and to be disciplined. There is no need to shoot everything that moves. We are interested in the highlights – the interesting or unusual.

Here are some ideas for the most common kind of shooting scenarios.

The holiday video

Your holiday is an ideal time to shoot. You are relaxed and away from the stress of everyday concerns. You may be travelling many miles and seeing sights you might never see again. You have the time to get to know your equipment and to experiment. You can bring back a wealth of footage. Do not over do it however. Make it quality not quantity! Here are the basics:

- Take your camera with you everywhere.
- If travelling with children, if they are old enough, film them describing where they are and what they are doing.
- Capture place names and hotel names.
- Record the local colour including music and people.
- Take great care if using a camera on the beach.
- Shoot from moving vehicles but not if you're driving!
- Look out for sunsets, seascapes and possible title shots.
- Be sure that you do not cause offence. You may need to give a tip, particularly if shooting people in national costumes.

The wedding video

If someone asks you to video their wedding, have a good think before you agree and perhaps read this book! A wedding is a once in a lifetime experience, (for some people!) You will get no thanks if the video is dark, boring and jerky.

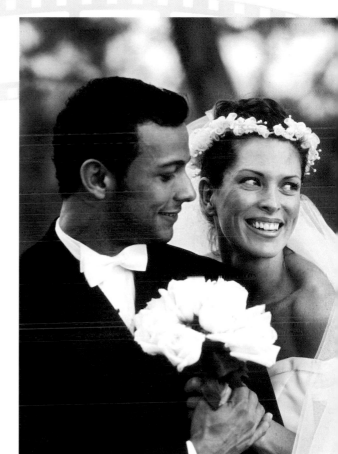

- Use a tripod if possible; it can be tiring to hold the camera for long periods.
- Check out the church in advance or at least earlier in the day.
- Ensure that the church allows videoing inside.
- Arrange a position at the altar to capture the actual moment.
- Find out if the happy couple have a favourite piece of music.
- Find a position that allows you to shoot away from windows.
- You will need to leave the church early so that you can capture them coming out of the church.
- There is plenty of waiting around. Use the time to get shots of all the guests including bridegrooms and pageboys.
- Follow the official photographer and get the group shots.
- Again, leave early and be in position for when the bride and groom leave for the reception.
- At the reception shoot the cake and floral decorations, etc.
- Once edited, keep the raw original footage and later give it to the newly weds.
- Collect up any wedding paraphernalia such as invitations, programmes, pictures that you can add to the video later.
- Keep the edited version to well under 15 minutes. (They can always watch the raw footage!)

The christening video

A christening is quite a challenge. Some are quite long and you need to make a decision about how much to capture. You need to concentrate on the key moments such as the arrival, the opening of the service, wetting the baby's head at the font and departures.

- Check out the church for camera positions.
- Don't forget the star, crying or not.
- Sound is difficult – can you get a mike close to the font?
- Use a tripod if possible
- Capture all the guests.

The childbirth video

Now this is a controversial area, but it is a wonderful occasion to mark with a video. There are people who shoot the actual birth but a video made just afterwards, as people arrive to visit is much more likely to be watched. A hospital is usually totally unsuitable for video, with harsh fluorescent lights and there is little you can do about it.

Rather than use this occasion on its own, its might be better as part of a compilation of the baby's first six months.

- Remember mother and baby may not be at their best. Ask first.
- Try to feature all who visit, including the nurses.
- Do not use a tripod and keep it discreet.
- Avoid getting in the way.
- Try to capture mum and baby leaving hospital for the first time.
- Baby's first bath is essential.

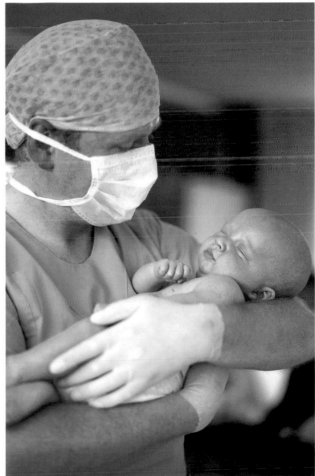

The party video

A child's birthday party is a very busy time. If it is your child it might be best for you to ask someone else to shoot for you. All the usual rules for shooting indoors apply. Try to get down on the child's level rather than filming from on high.

- Get plenty of shots of cake, balloons, birthday tea, etc.
- Film plenty of footage of the star of the day.
- If shooting a game, try to keep recording while changing the shot from one child to another.
- If sitting at a table try tracking slowly around.
- Be ready for the 'Happy Birthday to You' moment and the present opening.

The Christmas video

If you are not careful all your Christmas videos will look similar. Try to use a different technique each time. This is where some clever focus tricks and effects such as sepia can come in. Do not shoot it all over a couple of days. Start early.

- You might get a couple of shots in November of the making of Xmas pudding.
- Xmas decorations going up and Xmas tree being bought home.
- Identify some suitable music; there is a huge amount to choose from.
- Present wrapping.
- Decorating the house and tree.

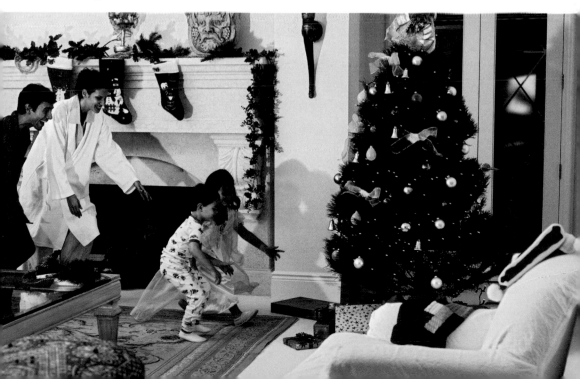

The toddler video

By the time a child reaches two or three years old they are into everything and already have quite a large vocabulary. This is a great time to capture them and listen to them speak, but it's also quite a difficult task because they do not stand still for very long.

- Try to shoot outdoors on a bright, dry day.
- Hand the camera over to them to have a go – under close supervision of course.
- Get down to their height.
- Close shots are the most effective.

The school play video

The school play is normally a disaster for reasons of a lack of control of your environment. The acoustics are normally very poor and the shooting position, as a member of the audience is a non-starter, with the stage often obscured by the head in front of you.

There are a number of things you can do, but rule number one is not to attempt to cover the whole thing, unless you are providing the official video of the event. If you are, you will need to consider camera positions, getting a mike close to the stage and using some of the techniques in this book.

If, on the other hand, you just want to capture young James, do a bit of research and find out which bits he is in.

- If you cannot change position, change the shot using the zoom.
- Do not get in the way of others; ask if you can move to the aisle.
- If you can see a rehearsal in advance you will know what to cover.
- Bear in mind that some official videos offered for sale will not be much better than yours.
- Use a tripod if you can get permission.
- Get as close to the action as possible.

The sports video

Videoing a sports match is a popular activity. However, it is best to be aware of your limitations. Television and sports have been associated for many years, but sports events are shot using many cameras and a specialist commentary team. The key here is to obtain some interesting action footage to compile your own highlights.

- A monopod is useful for support and is easy to carry.
- Remain on the same side of the pitch or action but obtain footage from several different positions.
- Use quiet moments to obtain cutaways of the spectators, referee, etc.
- During the action keep focused on the ball.

The barbeque or picnic video

Nobody will want to sit through every detail of you picnic or barbeque. The object every time is to create an interesting and creative short video of the highlights of the event. For example, you might start a shot on a view or blue sky, then slowly pan or tilt down to the family group arriving. Shoot whenever there is an opportunity – the really creative bit comes in the edit.

- Shoot the food.
- Establish where it is taking place. Find a creative shot.
- The kids enjoying themselves.
- The host cooking.
- Bottles of wine being opened
- Food laid out on table on ground.

MAKING

SHORT FILMS

Once you have mastered the basics of home video, you may soon want to begin making your own short films, indeed you might have bought your equipment solely for this purpose.

Feature films intended for theatrical release are normally shot on 35mm film. Films and drama intended for television will normally be shot on Super 16. This is similar to 16mm film but has a wider frame area on the negative. However, many TV series now shoot on video using the Betacam format. Equipment and stock is cheaper to hire and the quality of the pictures is such that many budding TV directors now use DV (digital video) to make their films.

Shooting on film is a huge commitment, requiring larger crews (cameraman, focus puller and clapper loader) and costly film stock and processing. Whilst there are people who still use film for their own purposes, DV is becoming widely used.

It is best to begin with 'shorts'. These are about ten minutes in length and used to be called 'one-reelers', because one reel of film runs for approximately ten minutes. As you become more experienced you can increase the length.

Script

Every feature film, or television drama begins with a script. This is the single most important stage in making any film. If you have an idea for a short film, first write it out as a 'treatment' or a synopsis. Do not try to write dialogue at this stage, just a few pages giving the main story outline and characters, etc. Although everyone thinks they can write, few people have real talent to tell a story, write convincing dialogue and bring characters to life. Unless you have abilities in this area, it is best to hand your treatment to a writer who will flesh out the details and write the screenplay.

```
NT:/ THE PUB
THE PARTYGOERS ALL ARE LAUGHING AND JOKING.  SAM AND DICK ARE
BEHIND THE BAR.

                         DICK
             SAM, HAVE YOU SEEN ROGER?

                         SAM
          YEAH, I THINK HE'S OUT ON THE SQUARE.

                         DICK
                         WHAT?

                         SAM
               HE'S TAKIN' A BREAK.

                         DICK
            HE'S SUPPOSED TO BE WORKING.

                         SAM
      OH COME ON DICK, LEAVE IT OUT.  IT'S NEW YEAR'S EVE.

                         DICK
                         SO?

                         SAM
          HE PUT A LOT OF WORK INTO THIS PARTY.

                         DICK
             DOESN'T MEAN HE CAN SLACK OFF

                 SAM (SHOUTING IRATELY)
       WELL, HIS BROTHER JUST DIED, SO MAYBE IT DOES!

     THE PUB GOES A BIT QUIET.  SHE CALMS DOWN SLIGHTLY.

COME ON DICK; THINK HOW YOU FELT WHEN CHAS DIED. JUST GIVE
HIM A BIT OF TIME TO GET HIS HEAD TOGETHER.  WE'RE DOIN' JUST
                  FINE WITHOUT HIM.
```

Funding

Once you have your script, you will need to think about the likely cost. This is known as budgeting and scheduling. Break the script down into the following areas and put a rough cost against each.

Actors **How many and will they work for nothing?**

Locations **How many and likely cost.**

Equipment **Beg, buy and borrow.**

Crewing **You can advertise for crew at low or no pay on www.shootingpeople.com**

So the total cost need not be great, providing you do not intend to pay professional rates. Crews will work in order to gain experience and many of them, and perhaps your friends will have equipment that can be borrowed for the shoot.

Planning the shoot

A ten-minute film should take you about two days to shoot. However you may have several locations to use each day so you will need to create a detailed schedule, listing the equipment you will require, the scenes you are shooting and which actors you will need each day. Take into account the weather and protection that you might need for the equipment.

Friday 11th June
10.30 – 17.30
Interior Sally's Flat: Sally, Tom
Props: Hoover, cup of coffee,
 TV remote
Equipment:: Battery lights

Saturday 12th June
08.30 – 17.30
Garden Exterior: Sally
Props: Shears

Equipment:: Reflectors

Sunday 13th June
08.30 – 17.30
Street: Tom
Props: Newspaper

Equipment::Reflectors

Batteries and chargers are a major factor, particularly if outdoors for the day. The minimum number of camera batteries you should take with you is three. One for shooting, one fully charged and ready in the camera bag, and one, preferably two, on charge nearby. Use batteries rather than AC power because it keeps the camera flexible and quick to move. If you are shooting for long periods indoors, however, in a relatively static position, such as for interviews, then you could use mains power with batteries as standby.

Basic equipment list

Keep the equipment tidy, clearly marked, close to hand and secure. The following comprises the minimum equipment list for a basic exterior or interior 'available light' shoot.

- Tripod with fluid head ☐
- Video camera & filters ☐
- Batteries ☐
- Spare tapes ☐
- Microphone and boom (a long extending pole) ☐
- Headphones ☐
- Battery chargers and mains lead/extension power cables ☐
- Multi-way plug leads ☐
- Masking tape for making cables safe ☐
- Chalk, markers, camera tape and duster ☐
- Large umbrellas and protective clothing ☐
- Camera bag ☐
- Continuity pads or notebooks ☐
- First aid kit ☐
- Sun cream or warm clothes if working outdoors ☐

Crewing

For economic reasons you will have a minimum crew. If your film requires interior shooting, you will need some expertise in lighting and additional equipment. However, the minimum you can have for an exterior shoot will be:

- Director
- Camera operator – may also be director.
- Boom operator
- Production assistant (continuity)
- Runner/ assistant – optional

Everything else such as costume, make-up, design and props will have to be pre-planned and sorted by you (director or camera operator) on the day. You and your crew will need coffee and tea and something to eat, so prepare in advance and take catering with you.

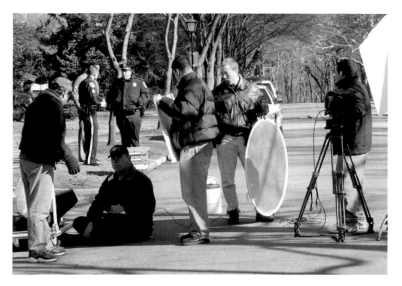

Keep your crew happy

Working with actors

Working with actors is one of the harder aspects of a director's job when making any type of film. Good casting is essential, but do remember that there are thousands of good but unemployed actors willing to work for nothing just so that they have something to add to their 'showreel' (a sample of work they have done to be given to professional casting directors).

When casting, make sure you do not allow the artistic area of your brain to block the practical, common sense side. Being right for the part is not the only thing to take into consideration when casting. Other factors also need to be assessed, such as:

Reliability: Will the actor show up on time with lines learnt, or will he/she leave you waiting and paying out for extra days shooting?

Image: Although your own perception of an actor may be that they are perfect for the part, if you intend to release the film you need to assess whether the viewing public will feel the same way.

Manner: Are they polite and courteous, or are they going to cause a fuss and walk off of the location because there isn't enough hot coffee?

The director's job in relation to actors is to convey his/her opinion of the character and the way that they think it should be played. This is often the point at which in professional films 'artistic differences' are often mentioned. Actors have an illustrious reputation for disagreeing with the director's approach to a film. Be diplomatic, and remember that you are most probably not paying the actors. Here are a few ways to maintain a good working relationship with your artists:

Scheduling: Do not have actors on set unnecessarily. Acting is a very difficult profession, and waiting around in the cold all day doing nothing will only frustrate them further.

Crew: Make sure that your crew work in a professional manner, and are courteous at all times. Signs that they are inexperienced, unprofessional or rude could make a good actor reluctant to work with you again.

Information: Be sure that the actor has all of the information about a shoot. Actors who are late because they were misinformed about the location could cost in extra shooting days.

Tolerance: No matter how small the role, many actors will tell you that they need to find their 'motivation' for the character. This stems from 'method' acting, which is a complex system devised to allow an actor to truly 'be' the character. Noel Coward's advice to 'learn your lines, be on time and try not to

bump into the furniture' may not go down well with such people, so try to accommodate them with whatever characterisation they need. However, do not be reluctant to bring them back down to earth if their attitude is problematic for the shoot.

Try to remember that just as they will be pleased to have made a positive contact in you, you could have made one in them. Actors can often go from relative obscurity to stardom in a matter of years, so try to keep in contact and find out what they are up to.

A good actor is someone who can portray a character with sensitivity, naturalism and emotion. The audience should be practically unaware that the actor is even acting if he plays the part with truth and reality, and not with perceived caricatures. The majority of people think that actors have to be good liars to be successful. In reality, the most prolific actors all achieve success from being truthful. Bad actors are generally bad because they use the tone, voice pitch and facial expressions that they perceive the audience would expect them to use in any given situation. Good actors will strip all of this away, and simply be left with poignant moments of intensity, that are powerful because they are real and what the actor truly believes he/she would feel in that situation. If you can achieve this then you have succeeded in directing your actors.

Recce your location

For a successful shoot you will need to have checked out your locations beforehand. This is called a recce (from 'reconnoitre'). These are the key areas to check:

- Check the potential camera positions.

- If interior, where are the windows?

- Is there an AC power socket nearby?

- Is there any ambient noise that might affect your ability to record clean sound?

- If exterior, where will the sun rise and set?

- How busy is the site?

- Is there any weather cover, should it be raining?

- How often do aircraft fly overhead?

- Plan where you will place your actors – avoid wide-open spaces, try to find a background to place them against.

- You might need to think about props, for example a bench or log for the actors to sit on.

- Where is the nearest car park and how close can you get the gear?

- Are there any changing facilities for the actors?

- Where are the nearest toilets?

The shoot

Arrive early. Explain the day's work, particularly to the actors and camera operator. Prepare the first shot and attempt a rehearsal. This is called blocking and it needs to be done swiftly. Work with the actors and mark their positions, if necessary, on the ground where they need to stop. Rehearse with the actors while final preparations are being made to the camera. If a fairly static simple shot, check the framing and go for a take. If more complex, involving either the actors or camera moving, then have a full camera rehearsal prior to shooting. You do not want to have to come back. Ensure you do everything that is required at this location.

Nothing worries actors more than a director who does not know what to do. You need to be confident and inclusive.

It is important to identify each shot with a verbal ident (identification). This is helpful to the editor. So the ident might be Scene 2, shot 11, take 1. If you have listed your shots on the script, shot 11 can be identified. If you have not, then say what the shot is, for example, 'Shot 11, two-shot, Mandy and George'.

The first take is very important because it is often spontaneous, has energy and will probably be the best. A director knows when the performances have reached a point to commit to tape. The director can watch the take in the pull-out monitor or in a larger size monitor, which can be connected directly to the camera. Shoot several takes of each set-up as necessary. Hold the final frame for as

long as possible before shouting, 'cut'. This will allow time for the editor to hold a shot if the scene demands and also add a mix if required. If you do need to review the shot in the camera, holding the shot will make it easier to reset and still maintain time code (See Chapter 3.) When happy, move onto the next planned set-up, and so on, until the end of a very exhausting day!

Don't forget to thank your actors, crew and location owners. This last category will have been very patient. If you agreed a fee, ensure that they are paid swiftly and above all leave the site clean and tidy. This will ensure a happy welcome for the next team who wants to use the location.

Continuity

During the shoot your PA (production assistant) will be noting all aspects of continuity very carefully. The PA will check each shot, how it will cut to the next and will log each one. Costume needs to be checked and noted or photographs taken. As you are shooting out of order, every single detail must be noticed and photographed or written down to ensure that when you return to this point in the story there will be no continuity errors.

Continuity errors

Typical errors are a change in the clothes of someone between shots or clock time variation between shots. A very obvious error comes in using action props. Smoking and drinking scenes need special attention to ensure that the level of drink and of cigarette remaining, are at the correct level between shots. Polaroid cameras can be used to record this, but stock is expensive. A good continuity PA can save an awful lot of re-shooting.

Unexpected emergencies

Even though your planning has been faultless and everyone has been working hard, it is usually the unexpected that throws the best-laid plans into chaos:

Equipment failure: The camera is your most important piece of kit. Usually it is not possible to carry a spare one. On the other hand they are extremely reliable. There is, however, a factor called 'dew' which will cause it to shutdown. Condensation is caused when you move it from a warm environment to a cold one or vice-versa. If the camera detects condensation, it will shut down. You can only prevent this by avoiding exposing your camera to extremes of temperature. If your camera does shut down, bring it into a warm environment and open the tape door to help evaporate the condensation. If you are moving from a warm interior to a very cold exterior, wrap a towel around the camera and in about 20 minutes, it will have adjusted to the outside temperature.

Injury: Although you have taken all the precautions you can think of, someone will probably bang their head, or get stung by a wasp, or fall down a hole. Always carry a small first aid kit. If you are in charge of the film, you will be responsible for any injuries.

Cast and crew discomfort: This can happen on a very hot day. Have sun screen available. On very cold or wet days, shooting outdoors can be very uncomfortable. Respond to the crew and keep an eye on them. Constant hot drinks will be required.

Sound problems: A circling aircraft or helicopter can prevent you from obtaining clean sound. A nearby road may sound a lot louder in the headphones than it did on the recce.

Bad weather: As you know, weather forecasts are often wrong. Try to have an alternative plan, known as weather cover, to move indoors or at least under some sort of cover if the heavens open. Above all keep the equipment dry and the actors warm.

Difficult location owner: The farmer who owns the field will claim he knows nothing about you and expects you to get off his land. Always ensure that you have sought permission from the person who is authorised to give it.

Post-production

This is a similar process whether making a home video or a feature film. The only major difference will be the amount of hard drive storage needed. Post-production is detailed later on, but if you are shooting a short film on DV it is possible to give your pictures shot on video, something like a film effect. Video doesn't look like film for a number of reasons:

Video shoots 50 or 60 picture frames per second (depending on the television system in question) and film shoots only 24. This makes video motion much smoother and more like watching the real world or a stage play.

The second way in which video looks different from film is that video applies an artificial edge enhancement to correct a problem inherent in CRT video displays. Some cameras let you adjust the amount of added edge enhancement via a 'sharpness' adjustment. Lowering sharpness a little will soften edges and give more of a film look. You can also achieve something similar by means of a pro-mist or similar filter.

Finally, video cameras respond to light differently from film cameras. A video camera has a much narrower contrast range that it can handle and the limits of its brightness range are more sharply defined, whereas film grades off more gently into pure white and pure black.

Setting exposure for film typically involves adjusting exposure to match the midpoint of the film's sensitivity range to the midpoint of the brightness range of what you're shooting. With video's narrow contrast range, this can sometimes lead to bright areas that become washed-out, glaring, 'electronic' white

Likewise, you usually don't want large areas of pure black with no interior detail. Use a fill light or a reflector to bring up some detail in the shadow areas.

Lighting as described earlier is key to creating the right atmosphere and can also make your video look more like film. Always use soft, bounce light (see page 117).

None of these things will make video look exactly like film, but they will give it what is known as a film look.

Finally, it is possible to shoot your video very cleanly and add film effects electronically. This process is very effective and after it is done, it is hard to tell the original shooting medium. An experienced camera person will advise on how to approach this.

Release forms

If you are intending to use your video for anything other than private use, you will need to get the performers and crew to sign a release form giving you permission to sell or show their work. This will avoid getting into arguments at a later date if the video should be exploited. This can be a simple one-sheet contract.

RECORDING SOUND

Home videos are usually associated with poor audio but this does not have to be the case. In concentrating so much on the pictures, it is easy to ignore the sound. The quality of the sound is one of the main aspects that can show the difference between the professionals and the home enthusiasts. Poor sound such as wind noise, a change of background sound, or music on each shot can ruin a video and render dialogue virtually inaudible .

When films are made, the sound is recorded separately to the pictures using a high quality DAT recorder operated by the sound recordist. The pictures and sound are then brought together at the transfer for the edit, using a clapperboard to synchronise the dialogue. This ensures that the dialogue can be heard, whatever the conditions.

ADR:
(Audio Dialogue Replacement)

Sometimes, when making narrative drama it is impossible to record sound. This is usually caused by conditions including bad weather and background noise. In this case, a guide track is recorded. (This is just whatever sound is possible from mikes close to the action.) The sound is then re-recorded by the artistes in a studio. It is very expensive and a specialist job to ensure that the new sound is synchronised with the pictures.

With home video the sound is recorded in the camera, on the tape containing the pictures. This means that you also record some camera motor noise (hum) and exterior noise between the camera and the subject.

In order to record clear, good quality sound, you need to get the microphone away from the camera and as close to the subject as possible. With the microphone built into the camera this is also the reason that wind noise becomes such a problem. However, there are a few basic solutions that can help, without the use of expensive equipment.

External microphone

Although the camera lens can zoom, the microphone cannot. This is a major factor in inaudible sound. However, you can purchase an external, hand-held microphone that plugs into the camera and automatically disconnects the internal mike. This has two advantages in that it removes the mike from the camera, thus eliminating motor noise and it gets the mike as close as possible to the sound source. Another advantage is that by changing the angle of the mike slightly you can eliminate much wind noise. You can also buy a lapel mike that clips onto the jacket or shirt of the person talking. Alternatively, you can conceal the mike close behind an object – on a desk or in a flowerpot, for example.

Wind protection

Use a windshield on the mike and use a pair of stereo headphones to monitor the sound during recording. You can also use a large golfing umbrella to shield the mike from the worst of the wind.

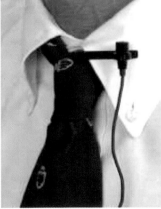

Sound boom

The most effective way of getting the mike in close without being seen, is to attach it to the end of a long pole (boom). You will, however, need someone to operate it. Hold it above the camera just out of shot, pointing down towards the subject. It will take some practice. You should mainly use this method for video when you wish to set up each shot specially. For the normal video of your holiday, for example, either use the onboard mike or hand-hold an external mike.

Radio mikes

It can be extremely difficult to use a boom mike on moving
subjects, particularly if using a long lens when the distance makes
it impossible to get a mike close. In these cases a radio mike is
normally used. These are expensive to buy, but if you only need
them for a couple of sequences, then you could consider hiring.
In order to use radio mikes, you need a clear line of sight
between the transmitter and microphone.

Frequency response

Sound travels through the air in waves. The closer the waves are together, the deeper the sound. The number of waves created in one second in known as its frequency. If a noise creates 100 waves per seconds, it has a frequency of 100Hz. The better the recording system, the more faithfully it can record a wide range of frequencies. Here are some typical frequencies:

Male voice 100-8,000Hz

Female voice 150-10,000Hz

Organ 10-20,000Hz

Flute 275-20,000Hz

Orchestra 40-20,000Hz

Standard audio 80-10,000Hz

Hi-fi audio 20-30,000Hz

Sound during recording

Before you begin recording, make sure that any extraneous noise – stereos, radios or TVs– are silenced. If not, you will notice a different background sound every time you change shot. You can lay on any effects or music afterwards if you wish, but if your original sound is not clean, you will be stuck with it.

Recording street bands

If you are out and about shooting close to a street band, for example, keep the camera in record mode throughout a particular piece of music, changing the shots as required. This will give you a continuous sound track. Continue for as long as you think the entire sequence will run.

For example, if shooting a brass band playing, press record as the band is about to begin playing a tune. Keep the camera in record for the whole piece of music and obtain as many different shots as you wish. Cut the camera when the band finishes. At the edit you can cut the best shots together, including any cutaways, although try to keep the band sequences roughly in order. You can then copy the music track and lay it back over your cut sequence and nobody will know the difference! Remember though, that when the conductor raises his arms at the end, to signal the final bar, you will have to ensure that the sound track is in sync with the picture! In other words, ensure that the sound finishes at the same moment as the pictures.

Ambient sound

Ambient sound is the term for the many background noises that occur naturally. Most of the time we do not hear them but when you play back your video, you certainly will. This sound will vary in differing locations and of course from interiors and exteriors. It is made up of sounds such as motor noise from camera or equipment, wind noise, birdsong and many other factors intermittently. Even if you think it is quiet you will be in for a surprise. Another term for this is 'atmosphere' (atmos).

Wildtracks

A wildtrack is the separate recording of atmosphere or specific sounds made with the intention of laying this back over the pictures at the edit. In order to achieve a balanced sound track it is important that the 'atmos' does not change noticeably between each shot. In order to prevent this you can record an atmos track or wildtrack. To do this, place the camera on a tripod or alternative solid base. (You cannot hand-hold.) Put the camera into record and ident the shot as atmos for xx scene. Then record a minute's worth of atmos ensuring that you keep absolutely quiet. This track can then be used and looped over other shots. If you are shooting in a room and your subject opens a window, you will need a background loop to slightly alter the sound atmosphere, for example.

Sound perspective

Perspective is normally associated with drawing and fine art, but it is also a key element of sound design. The perspective of the sound must always match the shot. This is quite obvious during a telephone conversation, for example, when the distant caller sounds tinny through the earpiece. It is less obvious in terms of shot size, though. For a tight single shot of a face, the microphone must be close up, the dialogue strong and clear, with little or no atmos. If we then cut to a two-shot of a couple standing by a tree, the dialogue must still be clear and audible, but it will be more distant with more atmos. If you watch a film or drama you will hear this in action.

Concerts and live music events

Live music events are difficult to capture properly and need planning in advance. If shooting a dance or pantomime, make sure that, rather than shooting the whole scene wide, you collect a selection of different sized shots that can be edited together, such as:

Wide shot of group
Tight shot of shoes
Pan up from shoes to faces
A tight two-shot of a couple dancing
A shot of a poster announcing 'Barn Dance'
Shot of the band
Band foreground, dancers background
Assorted close-ups of faces, instruments, etc.

At each change of shot, the music will also obviously cut, so that when you play it back, the music will be non-synchronous (a complete mess). Either you will have to find an opportunity to record the music separately, and then lay it back over the edited pictures, or find an alternative track to add. You cannot do this easily with speech, as the sound will be out of sync.

Rather than attempting to cover the whole event, just choose sections for which you will keep the camera running whilst adjusting the size of shots. In the edit you can cut an effective sequence with a continuous sound track.

At live events vary the shots and include close-ups, as well as wide group shots.

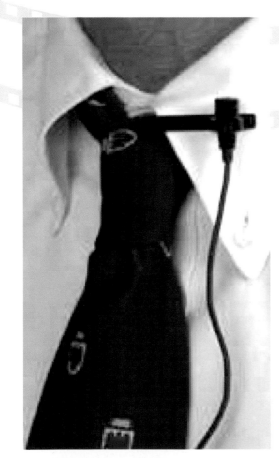

Lapel Microphone

Microphone technique

If you are setting up an interview or recording a voice-over for your video, there are two important aspects to consider. Firstly, the room or environment you will be recording in must be as quiet and dead (with little or no echo) as possible. There should be no background sounds at all.

Secondly, it is important to sit at the correct distance from the microphone to ensure a good balance. If too close, your breath will 'pop' the mike and it will also pick up your breathing and lip sounds. If too far away, the voice will be less clear and the mike could pick up more extraneous sounds. Ideally, try to sit with your mouth about 6-9 inches from the mike. You can use a windshield over the mike to reduce breath sounds.

Obviously, the quality of the microphone is also a factor, but for interview purposes, a lapel mike is adequate and quite inexpensive.

Voice-overs

Take care not to overdo voice-overs in videos. The pictures and soundtrack should speak for themselves. However, if you do decide you want to add one, it is a good idea to write the words in advance of the recording, by running the video and ensuring that the sequence fits the proposed script.

Normally it is necessary to record the sound whilst viewing the edited video. In this case you will have to try to find a position so that the monitor is well away from your computer workstation otherwise the mike will pick up machine noise from the computer. Ask different people to record voice-overs for you. It is not a good idea for the same voice to be heard on all your videos.

The sound should complement the visuals and provide additional information, not simply state the obvious. Do not speak just for the sake of it and when you view your edited video consider whether it will stand without any voice-over.

PICTURE

EDITING

Many camera users never get beyond shooting, viewing and put it away until next time. They perhaps think that to do anything else is too technical or time-consuming. This is a shame because if you can use a computer, editing is simple, enjoyable and quick.

Editing is just the process of removing the bits you do not need and reordering the shots to create more effective or interesting sequences.

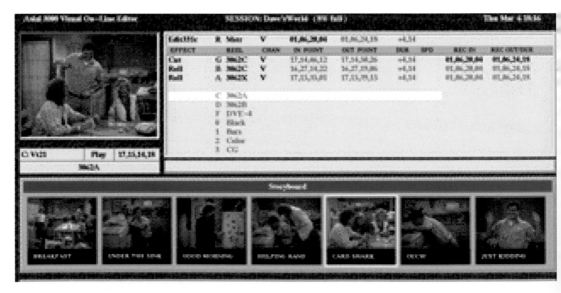

Editor showing timeline, monitor & project

In the beginning...

The very first TV broadcasts were live and the only medium for recording the early output was 35mm film. Live broadcasts used filmed inserts and eventually, entire programmes were recorded on film for transmission.

And this was how it continued until the invention of videotape.

In 1956 Ampex produced the first practical, broadcast quality VTR, (Video Tape Recorder). The VR-1000 recorded in black and white onto a 2-inch wide videotape. The picture was recorded across the tape from top to bottom using four recording heads rotating on a drum.(quadraplex). The invention of the rotating head was an innovation because previous attempts had required huge spools of tape running very fast to achieve the optimum recording speed of 15 inches per second.

In the 1960s videotape was still edited by cutting it with a razor blade, extracting the bit not needed, then gluing the remainder together in the same way as film-editing. To make a technically perfect splice, you 'developed' the tape. The developer was a solution containing fine metal particles that were attracted to the magnetised areas of the tape. This made the join invisible when the tape was played. It did, however, break occasionally, hence the 'normal service will be resumed' period of TV!

Capturing Stills: Old photos can be imported into your video.

Then in the mid-1960s it became possible to dub (copy) the bits you wanted from the playing machine to a blank tape set on a second recording machine; and this was essentially how it was done with various levels of automation, until the advent of non-linear, computer-based editing in the 1980s.

When video cameras for domestic use first came onto the market in the early 1980s, editing technology was impossibly expensive and only for the broadcasters. So there were two options available. One was to 'edit in the camera.' This basically meant that you planned your shots as you went along because you could only view your material in the order that you were shooting it. The advantage with this was that it was very quick and you could view your finished video as soon as you could connect it up to your TV. But for enthusiasts, it was very limiting.

The other option was 'linear editing' – to connect your camera to a top end VHS player with a flying head (the flying head meant that your edits between shots would be seamless) and transfer just the bits you wanted, in the correct order. It was also possible to add shot titles and music via an audio dubbing facility. This is recorded on the spare linear mono track. Many people still use this system. The name for this process is 'linear 'or 'sequence editing.'

Today, editing software for computers is cheap and most systems mimic professional software such as Avid and Final Cut Pro. Essentially, you plug your camera into the computer and transfer (digitise) your master tape in its entirety. You then make your video by dragging and dropping shots onto a timeline. You can

add music, effects, and graphics – there is no end to it! Once completed, you play the edited video out onto any format – currently either VHS or DVD. You can even email sequences to friends and family!

If you are new to editing, by far the best option is to ensure that you purchase a computer with the editing software already installed. Recent Windows and Apple Mac systems have a video editor included. On some basic systems the sound track is locked to the vision and therefore it can never go out of sync. Although slightly limiting, building up your sequence is very quick.

It is the edit that allows you to turn your raw master pictures into a polished video. Whether it is a feature film, a TV drama, a short film or home video, they are all edited in much the same way.

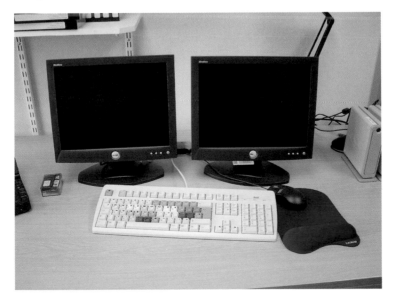

The theory of editing

You can join any shot to any other. However, you might think that it looks a bit odd or it could just feel uncomfortable. Therefore, it is important to understand why some edits do not work and what to do about it.

In deciding how to edit your video there are some simple rules to follow. Pace and style will be affected by the length of your shots. Try to cut different size shots together and build a sequence, bearing in mind that you may want to add music. This will give a completely different feel to the sequence. Give yourself as many choices as possible.

Shots that cut directly together should be sufficiently different from each other. So shots of the same person need to be a different size rather than just a different angle. As you play the shot you will probably find a natural cutting point; if in doubt, leave it long and trim it later. Both dialogue and action can give you natural cutting points. Use a head turn, for example, to cut, or a drink being put down on a table.

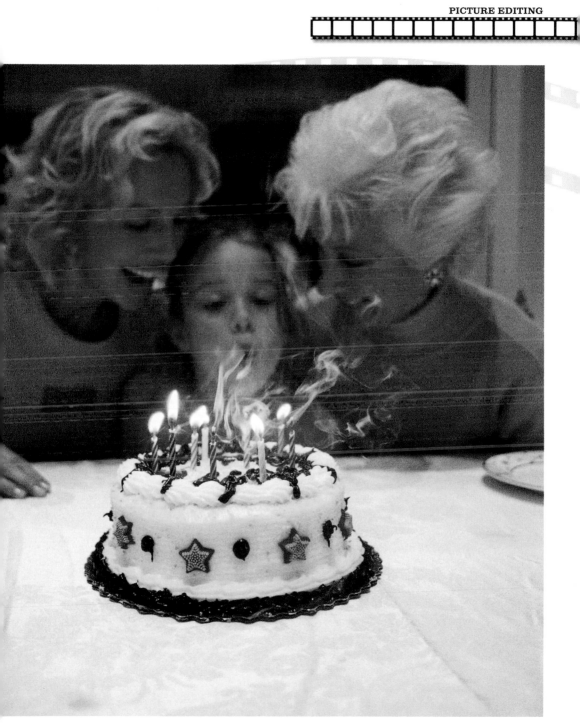

Here is a group of shots called 'The Birthday Party.'
Try assembling them into an interesting order.

1 Single shot of birthday cake
2 Group shot of kids eating jelly
3 Balloons with happy birthday
4 Kids leaving
5 Single of birthday girl eating
6 Single of birthday girl opening presents
7 Kids arriving
8 Plate of sausage rolls

For every single sequence, there are many different ways to cut
(edit) it together. Some videos are well edited and some are not.
For example in this case if you wished to use shots 5 and 6
together, there is clearly a passage of time between eating and
opening presents. You could add a mix, but I have used two food
shots placed between.

1 Kids arriving
2 Balloons with happy birthday
3 Group shot of kids eating jelly
4 Single of birthday girl eating
5 Single of birthday cake
6 Plate of sausage rolls
7 Single of birthday girl opening presents
8 Kids leaving

Timeline

The timeline is one of the most important aspects of your software: it is a visual representation of your edit, usually in the bottom third of your screen. It's your workbench. It shows the order you have assembled the material into, as well as every additional aspect such as music, effects and mixes. There are tools that allow you to insert a shot or delete a shot, with or without, leaving a gap in your video. By deleting a shot on your timeline, you do not delete the shot altogether. Remember, you are working with a copy of the master material. It is still quickly available should you wish to reinstate it. Unlike sequence editing, you can drop a shot into the middle and everything following moves along the timeline. This is known as insert editing. You build up your entire sequence and when complete, the computer makes your video by cutting the original master material using the editing decisions you have made. Many toolbars sit in the timeline enabling you to manipulate your material in any way you wish.

A jump cut

This is an inappropriate or disruptive edit that results in a breakdown of continuity. Jump cuts are often used intentionally in music and sports programmes. This is an example of a jump cut:

Shot 1: A boy leaves him home for a paper-round.
Shot 2: He arrives at the newsagent.

In cutting these two shots together, the boy must either leave the first shot or arrive into the second. If you cut from the first with the boy in shot to the second with him in shot – it will be a jump cut and not very pleasing.

Begin editing

This is a suggested order of how to proceed. Each stage is described in detail below or in the following chapters.

 Digitise your material and logging.

 Rough storyboard (shots in order).

 Fine cut assembly, (shots trimmed and now at correct length).

 Picture lock (in correct order, length and duration).

 Add transitions.

 Add titles/ graphics/ photographs.

 Select music and digitise.

 Add sound effects.

 Sound balance.

 Final review (check for dropped frames) .

 Transfer to VHS, DVD, Mini DV or email.

Digitise your material

Digitising is just a fancy word for getting your original material into the computer. (Injest is another.) Your master, high quality footage is transferred into files on the hard drive and then left alone. The computer also makes a lower quality (off line) copy of your video. You use these to manipulate into a completed video.

If you have lots of material to digitise, make sure that you switch off the PC's screen saver because this can interrupt the process. Ensure that your computer is recording both vision and the two stereo channels. You will be asked to assign a name to this material but you can change it later if you wish. Also at this point, digitise any music tracks that you might need later on.

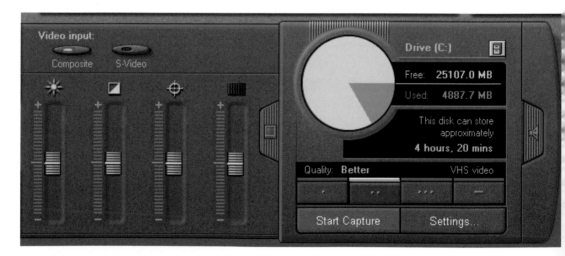

A computer's digitise screen.

Logging shots

As you transfer your material from the camera, watch closely and make notes. This is known as logging and will help you become familiar with the material. You will already have some ideas about the structure and you will have more as you view the material. Identify possible title shots and also sequences where the sound is important and should be kept, also identify sequences where wind noise means that the sound track needs replacement. If you already have some music tracks available make a note of these.

Storyboard

Some software allows you first of all to prepare a storyboard. This is just a very quick method of sorting your shots into a rough order. This is sometimes referred to as a rough assembly. You can change anything at any point so it is totally flexible. The thumbnails on your computer show just the first frame of your shot. As you trim a shot, the thumbnail will change so that you can always see the two shots that are cutting together.

(A storyboard is also a different term used by directors and art directors to plan complex stunts or effects sequences, sketching in frame by frame detail, in order to explain to all concerned what the overall structure looks like.)

Once you are ready to begin, drag and drop the shot down into the storyboard. It will not yet be the correct length but the object is to build up a very rough sequence. At this point, shots will not necessarily cut together.

Fine cut assembly,
(shots now at correct length)

Now you can begin the trimming process. Adjust the beginning and end of each shot so that it feels comfortable when cut to the next. A very small trim can make a great deal of difference. You can alter the order easily and add shots if you need to. At this point you can add music to a cut sequence as a guide track. This means that it gives you a rough idea of how the sequence might look and sound.

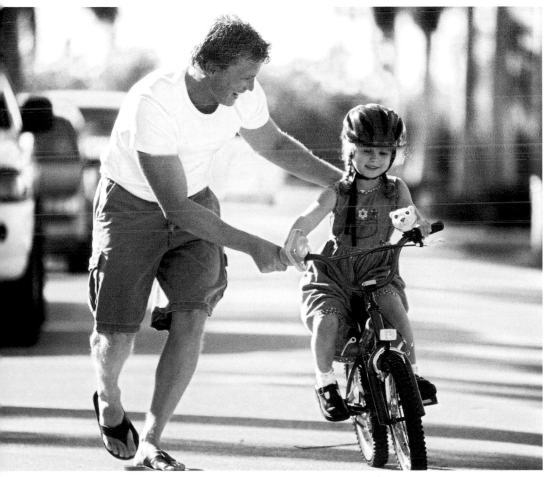

Picture lock (shots in correct order, length and duration)

This is the point at which you are happy with the pictures. Everything cuts together and is in the correct order. You can, of course, change this, but from now on, as you add more complex sound and titles and check for length, it becomes more time-consuming to make major picture changes. Do not let any of this put you off, though. If you want to start again – why not? It's your video!

Transitions

A transition is just a method of moving from one shot to the next. Unless you add a transition, one shot is simply 'cut' to the next. Most basic editing software comes with a series of mixes, dissolves or other wipes. Nothing could be easier: you just drag the transition onto the timeline at the appropriate point between the two shots and it is done. Usually there are far too many transitions to choose from, most of which you will never use. The essential ones are as follows:

 Fade up from black.

Fade into black.

Dissolve smoothly from one into the next, also known as a mix.

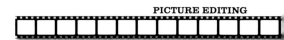

You can adjust the duration of all these. There are also a number of 'wipes'. A wipe is a transition but instead of happening at once, one part of the picture changes before other parts.

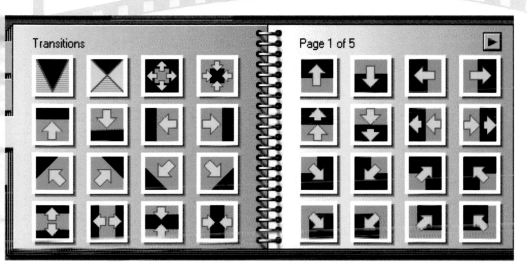

A dissolve is also sometimes used to indicate the passage of time. For example, a shot on board a coach dissolves through to arrival at the hotel reception. (This shows a passage of time and you have not shown the coach stopping, everyone getting off, getting their luggage and going into the hotel.)

Add a clock, countdown or fade up from black on the opening shot and a fade into black on the final shot. A change of place or time sometimes demands a mix. Although for some title sequences with music you might add a mix on every shot, as a rule, try to use them sparingly because they will be more effective. Slow dissolves between shots can be used to show a passage of time or to heighten tension during an action sequence.

Titles

It was not long ago that titles were written on pieces of black card and filmed. Early computers introduced animated, coloured, dancing letters which could be cut in. Now, of course, using the editing software available, you can create anything you can think of – and more. There is now what amounts to a powerful word processor within the editing software. This allows you to place titles of any colour, font or style anywhere in your video.

The title toolbar and interface of the editing software.

You can make titles for your video using many different software packages. However, most editing software comes with a good selection of titles already made up, offering many differing fonts and colours. You make your titles in a special title window, and then transfer them into your sequence.

Keep a title within one shot, lengthening the shot if necessary. It will look ugly if the shot changes under the title. Choose a colour that contrasts sharply with the background colour. For example, if you have a shot of the sea, avoid blue or green. You can add shadow or highlights to the text that allows it to show up clearly

Ensure that it is on the screen for the correct duration to enable it to be read easily. There are so many choices available that sometimes a simple white title is the most effective. Choose – or indeed shoot – a background that is not too cluttered and has room for your title (see illustration below).

It is important to add the date in your video at some point because the first question on viewing, will always be, 'when was it shot?' Adding titles to your video also points to reminders of places and location

Titles can be laid over black or superimposed over your shots. For a smooth, professional look, add a fade to each end so that the title fades smoothly in and out. Super (impose) over a shot of the correct length. Alternatively, you can shoot place names, signs or pointers to the location and cut these into the video. Although there are many choices, sometimes simplest is best: white, Arial, point size 50.

Within a short video, the size and style of lettering should be the same throughout. Once you have set-up a title that works, you can copy and paste it to the new position and then just retype the letters in the title box. This is a quick way to maintain the same style throughout.

Photographs

Most editing software allows you to add photographs to the
sequence. These can be full screen or within borders. You can make
entire sequences from photographs with music if you wish. You can
also use images from the Internet but take care as some are subject
to copyright. .

Adding other sources

Almost any visual or audio source can be input and edited.
Sometimes material that you want to use will only be available on
a VHS cassette, such as an underwater sequence shot by someone
else. You can import directly, but you may notice a loss of picture
quality. Alternatively, you can use a device known as a DV bridge,
which converts analogue video to digital quality and costs about
£200. CDs, Mini Discs and photographs can all be digitised and
used in your video.

Capturing stills

Editing software also allows you to capture stills from any suitable point in you video and cut them into your edit. Be aware, though, that you may have difficulty with the quality, if it is a very fast moving sequence.

These stills will not be as high quality as 35mm stills or digital photos. You can also scan your old photographs into the system.

Durations

Do not be tempted to make feature-length videos! Home videos are best in lots of short chunks over long periods of time. On a typical shoot you might capture an hour's worth of material. This is a fair size to deal with in the edit. The final edited duration might be ten minutes. Use only the best shots and sequences that help to tell the story and move it along. Nobody wants to sit through endless shots of passing landscape. Be brutal with yourself. Put yourself in the audience's shoes.

A popular duration for a video is around eight–ten minutes. You can, of course, edit to any duration you wish, but always edit long to begin with (rough assembly) and then tighten as you go. Keep it slick. Try turning it on its head and start at the end! As you become more practised, you can extend the final durations. Do not be afraid to try new things. You might also think about making several versions of differing durations. You can even make a short, punchy trailer.

Video effects

Animation

Complex multi-screen layering and animation can only be performed on expensive post-production equipment. Effects available in most modest editing software packages are limited to wipes and mixes. You can, however, buy additional add-ons to create particular effects, but remember that these will require additional memory and hard disc space.

Slow motion

Slow motion has a place if used sparingly. As with all effects, it is to be added at the edit rather than during the shoot. If your editing software does not support slow motion then you can use the camera's facility.

In this case, identify the shots that you require and digitise in slow motion. You can then cut them into your video in the normal way. Slow motion sequences will normally need music because the sound will be useless. For example, you could use a 'slow mo' sequence as the newly married couple come out of church and confetti is thrown. Digital video produces stunning slow motion shots. You might also use 'slow mo' for an opening or closing sequence. See right.

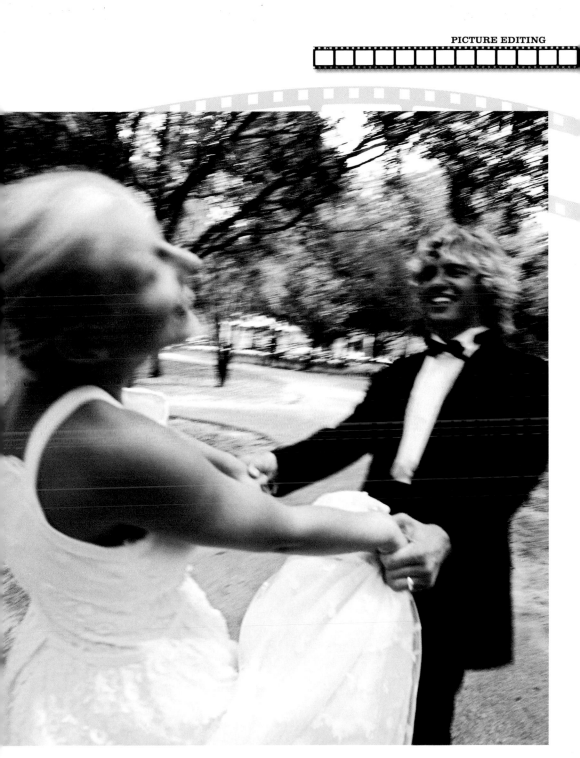

ADDING MUSIC
AND EFFECTS

Music and effects are vitally important in giving your video emotion and making it interesting, sad, funny or lively. Once you have assembled a rough sequence, you can begin to think about where music or effects might be appropriate. There will be some synchronous (actual spoken) sound that you will want to keep. There will also be some sequences where you have bad wind noise or the sound is of little consequence. In these cases, consider replacing the sound with music or effects tracks.

Music

The choice of suitable music is one of the most important decisions in making successful videos. It must obviously be appropriate and relevant to the occasion. You can use whole tracks or just part. If using part of a track, you might consider fading it in or out at the beginning or end.

Use your favourite pop music of the moment, or perhaps a track that was played constantly on your holiday. This will bring back all the memories and atmosphere of the occasion when you play it back. If you are abroad, have a look in gift shops for CDs relevant to the country, which you may not be able to obtain back home.

Once you have chosen the music, you must record it to a file within the software, (digitise) ready for you to drag onto the timeline. If possible record all the tracks into the system at once so that you can try out different tracks at different points in the video. If you wish, you can lay additional tracks down later. For some sequences you will want to time the shot cuts to the music. Roughly edit the pictures first, then drag the music track onto the timeline and trim the pictures to the music.

Music copyright

If you show your videos for family and friends only, you can use any music of your choice in videos.

However, if you intend to show them in any form of public forum, or sell them to any 3rd party or broadcaster, you will need to use either copyright-free music, or pay for its use. There is a huge variety available and you can obtain CDs or, alternatively, download from the Internet. Music is available for any occasion or from anywhere in the world.

Back-timing music

If you have a particular shot or sequence where you want the music to end but, rather than fade it out, you wish to hear the end of the track, simply position the end where you want it on the timeline. Then move to the beginning of the sequence and trim the beginning of the track to the start point and add a fade. Alternatively, if the music dips out at any point, you can time the next music cue and move the track on so that it ends at the correct point.

There are many albums of stock music available.

Sound Effects

Effects can be used either to replace poor sync sound, or alternatively to create an effect or enhance rather distant recorded sound . You can also record your own on location and then lay it back over the cut sequence. Sound effects CDs are commercially available or you can borrow them from local libraries. Editing software also comes with an array of sounds that you can easily drag onto the timeline. Again, you can drag and drop the effect, pull it down roughly in position in the timeline, then move, shorten, fade up or down as you wish.

Add the noise of champagne corks popping at wedding, for example. You can also create a complete atmosphere to a shot if the actual recorded sound is useless. Footage from a beach where there is no actual useful sound except wind noise could benefit from this. In this case choose a sound effects track and lay it down on the timeline. If there is some sound that you wish to keep, mix the two tracks together to help eliminate some of the wind noise.

Saving your video

If you are using an opening or closing sequence with titles and music, think of this as a separate chunk. You can bring the whole lot together at a later stage by cutting and pasting. Save your work regularly, particularly after a complex edit. Most software does an auto save and you can adjust how often this is done. It is frustrating to lose hours of work - so play safe and save your work as you go along. Most computers do crash from time to time!

Above: Some sound effects. To hear them just click on the effect.

Right: Store your videos and DVDs safely and make sure they are clearly labelled.

SOUND

EDITING

Sound editing and balancing the sound are important final stages in making your video. In this area, software is supplied with differing numbers of tracks and complexity, but a basic system should give you a mixer with three or four tracks.

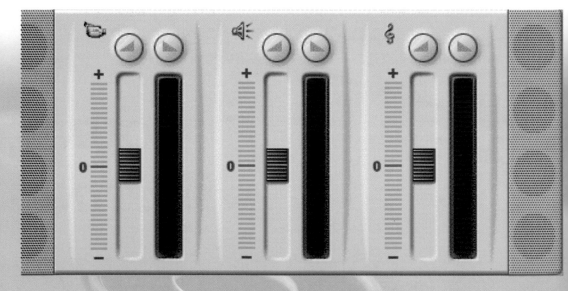

A typical audio mixer within editing software.

On the first track is the original sound, recorded when you made your video. A second track will be available for music. A third track is for sound effects and hopefully, a further track for any voice-overs. (If this is not available you can use the effects track.) You have the ability to hear these tracks on their own, or to mix them together. All of the tracks are stereo pairs, so there is a left and right channel for each track. Once mixed, you can make further adjustments, listening on a pair of stereo headphones. This is known as sound balancing.

Audio 1

This is the original sound from your edited shots. When picture editing, you will need to take into account the sound track in order to avoid cutting into a shot halfway through a sentence or word. On this track will be all the wind noise and atmosphere recorded at the time. It can be somewhat depressing to hear just how awful it is. However, there are other tracks available, which, if used properly, can save the day.

Audio 2

As mentioned earlier, music is vitally important and this is where it sits. On the audio 2 track you can move it physically and, of course, alter the volume relative to other tracks. If you use music in place of audio 1, then the music will dominate and the footage may feel like a music video. If you mix it with audio 1 and dip the volume up and down, the video comes to life but the music remains in the background. This one aspect can change the entire nature of the sequence.

Audio 3

This track, for sound effects, can be used in all sorts of ways but its contents normally sit in the background rather than dominate. If you have recorded an atmosphere track (see page173), this is where you will balance the volume to try to make it feel natural.

Audio 4

If recording a voice-over or narration, it can be added to this track. It is important to try to record in a quiet, acoustically dampened room. You require just the voice here with the minimum of atmosphere or outside noise. You can record it as one long take, then edit it into segments and move it around. If you only have three tracks you can use the effects track for voice-overs.

Looping

It is normal to record just a minute or so of atmosphere. If you do require it to cover a longer sequence, you can loop it by adding it again to Audio 3, ensuring that there is no gap between the tracks.

Sound mixing in real time

The other aspect that you will need to consider is the ability to fade sound up or down and to mix it with other sound sources. You can play sound from any source into your PC (given the right cables and connectors), but do avoid audiotapes because the sound quality is inferior to CDs or mini discs. With many systems you can mix in real time. This means that you play your video and dip and raise sound levels using the faders as you go. These levels are then remembered and will reproduce each time you run the sequence or video.

Panning sound

You can 'pan' the sound from stereo left to stereo right or vice versa; this is a useful effect when showing a train going past, for example. It creates a dramatic, sweeping effect and is most noticeable on a wide screen with a cinema surround sound system.

Balancing the sound

It is important to obtain the correct sound balance between music and original sound for playback. There should be a good balance of dialogue and real sound to music and sound effects. Very often you will need to eliminate wind or background noise.

Take care that your video has a consistent volume so that on playback, once the volume is set for the opening, it should not need to be touched again, in order to hear dialogue or any other parts of the video.

Feature films use a sound mixer with a large numbers of tracks available to mix from the many sources. 35mm film has two entirely separate sound tracks, the analogue and digital tracks. When played in a cinema, the digital Dolby sound tracks provide the fantastic surround sound. If a fault develops on the digital track, the projectors automatically switch over to the analogue tracks.

Although you have far fewer tracks and less sophisticated equipment available, you can still have very impressive stereo sound with the three or four tracks that you have available.

Lead incoming sound

If you listen and watch TV carefully, you will notice that quite often you can hear the incoming sound of a shot a few seconds before the picture appears. For example, we are inside a hospital ward and as the scene draws to an end, we hear a busy road. We then cut to another scene on a motorway bridge. This technique is known as 'leading the sound' and it is effective for keeping audience attention and increasing the pace of the sequence. This is easy to achieve in the edit, but you do need to separate the vision and sound tracks. Take care not to let these tracks get out of sync, however. All that is needed is to trim the incoming picture by a few seconds, leaving the incoming sound to cover part of the last shot.

TRANSFER

AND FINISHING

Colour bars & tone

In order to mark the start of the video and assist you in the transfer, you can add colour bars, tone and/or a countdown clock at the beginning. The tone allows you to check that you are recording stereo sound and the colour bars are to check vision and colour tones. The clock will count down from ten to three seconds then fade up into your first shot at zero. This also helps to mark the start point when making further copies.

Use Colour bars to mark the beginning of your video.

Preview

When you have finished editing, added your titles, music and balanced the sound, allow yourself a final viewing of the complete video from beginning to end. As you 'preview' and spot something you want to change, pause the sequence, normally by pressing the space bar once, make a note of it and then continue the viewing. Continue this process to the end; you can then make all the changes at once, having viewed the entire video. If you try to make changes once at a time, you can lose the sense of the entire video and never get to the end.

Ask yourself if anyone will want to sit through it. If in doubt ask a friend to view it with you and take their comments seriously! They will be coming to the material with a fresh pair of eyes and will be able to point out obvious things that you will have missed. Make changes if necessary, but try to avoid any major changes at this late stage.

Review (final viewing)

As you view, check that there are no edit judders. Sometimes a dropped frame can momentarily freeze the action. This is where a frame has been missed in the digitising process. You will need to trim these out. 8mm analogue cameras are prone to this, but it is rarely a problem with digital cameras. Check that the music is playing in stereo and is at the correct volume. For editing you should monitor the sound using speakers because headphones can become very uncomfortable over long periods. However, for the final review, use headphones in order to avoid distractions and to hear clearly.

Also ensure that in trimming the pictures, you have not inadvertently upset the timing of sequences already cut to music. Check that the titles are smooth and remain on the screen long enough to be read easily. Ensure that you have not left any unwanted shots or parts of shots within the body of the video. These are called 'flash frames' and can be difficult to spot. If in doubt, run the sequence very slowly. Once identified, position the cursor on the frame in the timeline and remove. Bear in mind that anything you delete now will affect your overall timings.

Rendering

This is the term for the computer to 'make' your final sequence. Once you have finished and checked (reviewed) the final edit carefully, the software automatically uses the EDL (Edit Decision List) to make your video but this time, uses the original master pictures, rather than the off-line quality ones you have been editing with. By matching the time code in and out points, the sequence is built up into your final video. This process can take some time depending how complex your editing has been (i.e. how many mixes, graphics and effects you have placed on the timeline). Some years ago when processing power was smaller, this process could take hours or even days. Nowadays a ten-minute video will be rendered in between three and ten minutes depending on complexity and the processing power of your PC.

Playout

This is the point when you commit. Once you press the button you will not be able to make any further changes without re-rendering. When the render is complete, you can tell the computer how and where to play the material out.

When ready to transfer to VHS, DVD or Mini DV, first check your connections. Before you begin, be sure to switch off your computer's screen saver because this can interrupt the process. To do this, point your mouse in a blank space on your desktop, click the right-hand button and select properties. Go to screen saver and select 'None.'

Your video will have to be transferred in real time, (i.e. a 30-minute video will take 30 minutes to transfer.) First though, check picture quality and sound. Providing that your TV monitor is showing the output from the computer, all should be fine. To double-check that all is ready, transfer just a few scenes, then replay and check picture and sound quality before going on to transfer the whole video. It is frustrating after 30 minutes to discover you have not recorded any sound!

Additional generated copies

Your master tape from the camera is known as a 'first generation master'. When you assemble the edit onto a VHS tape, this becomes second generation. If you then go on to make further copies from your edited version, these are known as third generation and the picture may be blurry with some colours bleeding into one another. The picture quality, compared with your original master tape, will be poor. So always strike additional copies from the edited master, rather than from copies.

One of the major advantages of digital technology, however, is that you can make as many copies as you wish and the picture quality is as good as when originally shot.

Sharing your work with others

In the same way that millions of photographs are taken, developed and then sit in cupboards never seeing the light of day, there are videos that sit on shelves and are never watched. It is hard to believe that so many people spend so much time and effort shooting their videos, yet never bother to share them with others. This is probably because your potential audience have already been subjected to typically disorganised videos with jolting pans, zooms all over the place and awful sound.

Remember your audience: they will want copies when they are eighteen!

Once you have read this book and started to make videos in a more professional way, you could surprise them with a well thought-out and edited programme with music, a good variety of camera angles and most important of all, smooth and steady shots. You might also consider tempting them with some food and drink. Of course if your guests feature in the video, so much the better.

Do take a few minutes to check the viewing conditions before anyone arrives. If possible view on a reasonably large set. If you have shot in widescreen format, ensure that the correct ratio is set on your TV. You will need 'widescreen' not 'smart' or any other setting. Check that your video or DVD is playing in stereo and that you have the correct audio setting. Some TV sets now have differing settings that are really just presets for the treble and bass. When a group is viewing and, God forbid, talking and laughing, you should choose a setting that gives a higher treble and lower bass. Also check the lighting conditions. Try to prevent ambient light from windows or lamps from spilling onto the screen. Change the angle if necessary. People do not really like watching TV in pitch darkness but at least try to reduce the light levels by switching off the main light, or some lamps.

One idea you might consider following a holiday or weekend break, with friends, is to arrange a 'reunion night.' So following a weekend to Barcelona, for example, you might arrange a 'Tapas' evening and round it off with a viewing of your video. One important point is to arrange it far enough ahead to allow you to complete the edit and prepare a really well packaged video. You will get a reputation – for good food at least!

Right: A DVD containing two hours of digital video.

ARCHIVING

Your completed videos are extremely valuable, as are the master tapes from which they were made. Videotape deteriorates over time and after many years it can begin to break down. This is because the magnetic oxide that coats the plastic tape becomes brittle and falls off to form a white powder. Videotape was invented in the 1950s so the very long-term outlook is still unknown, but already VHS tapes are becoming obsolete and DVD is the new recording medium. (Notice on repeats of old TV productions how the colour has already faded.) Even 35mm film fades eventually and has to be re-mastered.

The film director Stanley Kubrick (*2001: A Space Odyssey* and *A Clockwork Orange*) insisted on archiving his films at Rank, using the three-stripe process. This involved archiving three separate 35mm negatives for each film, one for each of the primary colours. When a new master was required, these three negatives could be projected together to create a brand new negative with colour as good as the day it was first made. But then he could afford it!

VHS tapes do deteriorate over time. The colour fades and dust and dirt transferred from the video heads can damage the tape on each playing, just like an old 33 rpm LP's. Here are some tips that can help make your videos last for a long time:

 Keep videotapes out of the basement! Moisture and humidity will damage them irreparably.

 Store upstairs in a cool, dry place. The ideal temperature is not less that 40°F and not more that 70°F.

 Always use standard recording speeds. Extended recording times will degrade your image from the beginning.

 Use the highest quality tapes you can afford and use only 60-, 120- or 180-minute tapes. On longer tapes, the plastic is thinner and more susceptible to damage.

 Make duplicate copies of master tapes. They will deteriorate with repeated playing.

 Always rewind your tapes and store them flap first, in the box.

 Carefully label and index what the tape contains.

 Never leave your tapes in direct sunlight or in a vehicle.

Most people currently transfer their final videos to VHS tape for viewing and storing. However, the final edited copy should always be stored on the highest quality medium. It is now possible to 'burn' your edited videos onto a DVD. Just like a CD, the playback heads never come into contact with the playing surface so there is less chance of damage to the recorded material. Although these machines are currently quite expensive (£400 £1,000) the cost is falling rapidly.

If you wish to archive onto VHS tapes, you should use brand-new high quality tapes of 60 or 120 minutes duration. Never use tapes that have been recorded on already, because these could already have damage which could affect your sound track at the very least. This is because the sound tracks are on the leading edge of a VHS tape and are likely to suffer damage from the recording heads when being played or rewound. Avoid using longer duration tapes as the plastic tape is thinner and is more likely to be damaged in the winding. You can transfer several finished videos onto one tape and mark it up carefully with details of format (Hi 8, etc), date, title – as much information as possible.

In many years you will have forgotten the content but at least you will be able to find it quickly. When full, do not forget to remove the tab from the back of the VHS cassette to prevent accidental erasure. Children tend to grab the nearest tape; so make sure they do not record *The Simpsons* on your prized holiday video! Tapes with the tab removed cannot be recorded on. If later you wish to re-record on the tape, you can apply a small piece of sticky tape across the hole.

	Name	Trimmed start	Movie duration	Movie start
1	Clip: 'Demo [40.19]'	0:00:40.19	0:00:13.19	0:00:00.00
2	Clip: 'Demo [59.12]'	0:00:59.12	0:00:07.11	0:00:13.19
3	Clip: 'Demo [2:23.02]'	0:02:23.02	0:00:03.11	0:00:21.05
4	Clip: 'Demo [3:14.02]'	0:03:14.02	0:00:09.03	0:00:24.16
5	Clip: 'Demo [3:23.05]'	0:03:23.05	0:00:08.12	0:00:33.19
6	Clip: 'Demo [2:23.02]'	0:02:23.02	0:00:03.11	0:00:42.06
7	Clip: 'Demo [2:53.22]'	0:02:53.22	0:00:13.24	0:00:45.17
8	Clip: 'Demo [2:20.03]'	0:02:20.03	0:00:02.24	0:00:59.16
9	Clip: 'Demo [2:26.13]'	0:02:26.13	0:00:27.09	0:01:02.15
10	Clip: 'Demo [4:10.06]'	0:04:10.06	0:00:04.10	0:01:29.24

Example of an Edit Decision List.

When playing out your tape from the master edit, think about how many copies you might need. If you wish to let friends have a copy or you want to send one abroad, make a spare working copy for yourself. Never copy to VHS tape from another VHS because the quality will be very poor. If you are mastering to a DVD, you can make further copies onto tape from the DVD master.

As well as creating an edited copy of your video, the computer software will also produce an EDL (Edit Decision List.) This is really just a list of time code in and out points. If you keep a copy of this, which is a very small file, on a floppy disc or CD, you will be able to go back and make another copy from your master recordings.

Most home editing computers will only have a limited amount of storage capacity on the hard drive/s. As they fill up, your computer will operate more slowly. (A computer with a 60 gigabyte hard drive can take about three hours of video in total.) Therefore when your video is transferred, it is best to delete the edited video, the original master material and all associated files. Just work with one project at a time. You can purchase additional drives if you wish to store more material.

Compilations

For very special occasions, such as a Golden Wedding or an 18th birthday, you might consider making a compilation tape. This could either be a stand-alone video or as part of a sequence in a longer one. A compilation will normally have a music track to link it together as the sound on the individual clips will be useless.

This can be quite a time-consuming operation because the clips will be coming from many different tapes, unlike a normal edit which tends to be digitised from one or two tapes.

The first thing to do is to select the shots you intend to use. If you do not have a playback deck, you will need to use your camera. To save unnecessary wear and tear, though, you should work through in a logical order. When you identify a clip that you want to use, digitise it straight away, allowing a few seconds on both the beginning and end. Give it a title or a letter or number that will allow you to recognise it. You can then log it separately. This is where identifying your tapes and their content is important and if you have marked them up, the task will be much easier.

Once the clips are all digitised you should also digitise your music track. Lay it down on the timeline and begin to build up your sequence in the normal way. In a compilation you may use more mixes than normal and it may take longer to render.

Archiving to tape

If you do not have access to a DVD recorder or a Mini DV then you can archive to VHS. However, for the reasons mentioned above, it is worth making two master copies for yourself from the playout. You can then use one to play and one to keep for the archive. This means that you have a back-up, unplayed copy which will keep in better condition and can be used for making further copies if necessary. This security copy will also be useful should the other tape become damaged. As VHS players get older, they do become prone to chew up the tape!

Mini DV

If you do have a Mini DV recording deck, you might consider archiving to Mini DV. The advantage is that the tapes are small to store and can be copied to any other format with no loss of quality. If you have the equipment I would suggest mastering to DVD and creating an additional spare copy on Mini DV for the archive.

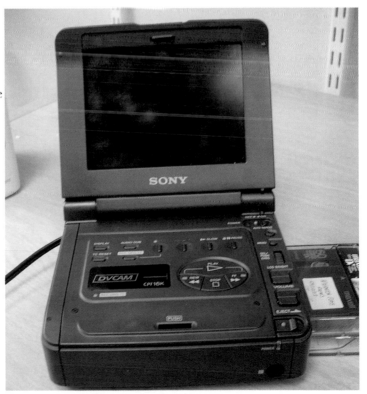

Right: A Mini DV recorder.

DVD

If you have a DVD (Digital Versatile Disc) recorder, you can put as many videos onto a disc as it will hold. This is usually around 2 hours of digital high quality video. Some machines provide a thumbnail picture index (a still from each video) on the main menu or alternatively a menu. This makes it incredibly easy to start any track instantly. The quality will be as recorded with, if you wish, widescreen digital pictures and stereo sound. Sound quality on a DVD is superior to videotape. The DVD format is still fighting for supremacy a little like VHS and Betamax in the 1970s. Here are some of the current differences:

DVD RAM: These discs can only be played on a DVD recorder but they do allow editing and have visual picture menus. Also, you can play back a programme whilst it is still recording the end of it.

DVD-R: Once you have recorded your videos and the disc is full, you then finalise it, which means they can then be played back on any DVD player. These are currently the most versatile of discs.

Some computers now have a DVD burner as standard but you will need to use DVD-R discs in order to play on other DVD players. You can only record once onto these discs, but you can add an index on the menu. Once the whole disc is complete and fully indexed you 'finalise.' This only takes a few minutes and once done, the DVD can no longer be recorded on. It is now exactly the same as those for sale or rent and can be played back on most DVD machines. Blank DVDs cost around £2 each and the price is falling rapidly.

With one of these machines you can gradually transfer your collection of precious video memories from over the years, and provide an insight into your family's life and times for future generations. The sounds and moving pictures of the past may well be as valuable one day as the diaries that Samuel Pepys left behind.

So, as they shout at the end of a shoot, 'it's a wrap.' That is the end of your video and of this book. As a final bit of techno babble, the word 'wrap' comes from the early days of feature film production in California. What do the letters stand for?

WIND, REEL AND PRINT.

Good Shooting!

GLOSSARY

CCD Charge Coupled Device

CRT Cathode Ray Tube

C/U Close-Up

Capture Shooting and recording your video

Cut The most common way to move from one shot to the next
 DAT Digital Audio Tape

Dub To make a copy

DV Digital Video

DVD Digital Versatile Disc

Digitise Transferring video into a computer

Duplex Linking two VT machines together

EDL Edit Decision List

Master Original film, tape or negative used for the recordings.

PAL The UK TV System of 625 Parallel Alternating Lines

Pan A movement of the camera through a horizontal arc in a
 static position

Quadraplex The system of using four recording heads on a Video
 Tape Recorder

Track The camera itself moves through a horizontal arc.

SFX Sound Effects

V/O Voice-over

VHS Video Home System

VCR Video Cassette Recorder

VTR VideoTape Recorder

BIBLIOGRAPHY

Camcorder Basics by John Hedgecoe

Taking Better Videos by Caswell Camera wise guides

Camcorder Questions and Answers by Steve Parker

The Camcorder Handbook by Malcolm Squires

*The Complete Idiots Guide to making Home Video*s by Steven Beal

Photography by Michael Busselle

Sermons, Soap and Television by John Logie Baird

INDEX

CREDITS & ACKNOWLEDGEMENTS

John Logie Baird – who invented television.

William Taynton – who first appeared on television.

Jo Czarnecki – illustrator

Corrinne Czarnecki – illustrator

Christine Collyer – who asked me to write this book.

James Taylor – actor in waiting.

David Nixon – who inspired me to a career n TV.

Picture credits:

Photographs pp 39, 61, 65, 67, 77, 82, 88-88, 9-93, 96-97, 101, 105, 109-111, 118, 122, 127, 129, 131-135, 143, 151, 153, 172, 175, 185, 193, 200, 203, 207, 211, 223, 229, 233. © Stockbyte. Photographs pp 63, 90, 102-104, 117, 136-137, 160, 171. © Getty Images.